GHOST RANCH
Land of Light

G H O

Balcony Press Los Angeles

RANCH
Land of Light

The Photographs of

Janet Russek and David Scheinbaum

First Printing

Ghost Ranch: Land of Light

© 1997 Janet Russek, David Scheinbaum, Edward T. Hall, Lesley Poling-Kempes, Rina Swentzell

Design by Kurt Hauser

Imaging and printing by Navigator Press, Pasadena, California

Library of Congress Catalog Card Number: 97-070674

ISBN 0-9643119-8-4 paperback
ISBN 0-9643119-9-2 hardcover

These photographs are the subject of exhibits at The Albuquerque Museum, January 11 — March 29, 1998 and the Museum of Fine Arts, Museum of New Mexico, Santa Fe, May 1 — August 2, 1998.

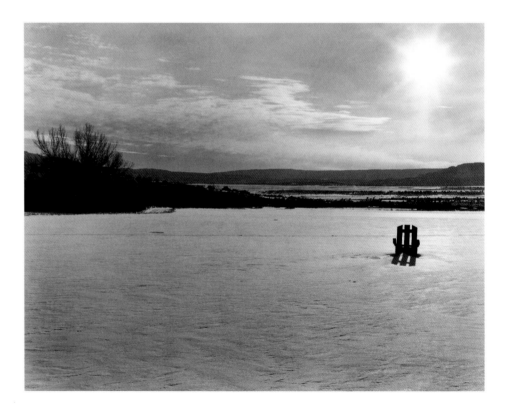

CONTENTS

To our mentors Beaumont Newhall and Eliot Porter for their constant inspiration and friendship. To our children, Jonathan and Andra Russek and Zachary Scheinbaum, who have always supported and tolerated our stopping to photograph. To Janet's mother, Esther Goldberg, for her devotion and support, whose company was always welcome on our many journeys through the southwest, and who on first seeing the Piedra Lumbre area believed it to be surely one of the most beautiful places on earth.

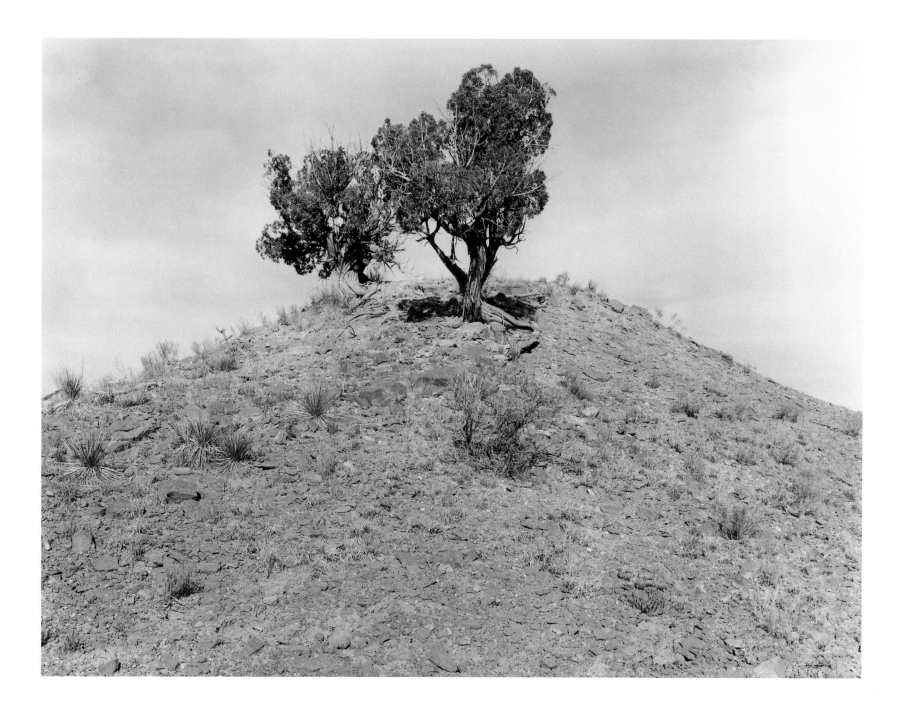

INTRODUCTION

The bonds between the landscape and humans are strong as well as deep, and while these bonds are not commonly chosen as a route to insights into our relationship to the landscape, *Ghost Ranch: Land of Light* shows promise for doing just that. *Ghost Ranch* utilizes and explores some of the unwritten rules of space, gender and ethnicity and in so doing, engages the viewer in a new way.

I can still see in my mind's eye my first glimpse of the New Mexico landscape. My first experience with this magic country occurred seventy-seven years ago in April of 1919 when my mother, sister, baby brother and I took the train from El Paso to Lamy.

My previous experience with space was the first four years of my life in Webster Groves, Missouri, a suburb of St. Louis, when there were days that the smog downtown was dense enough to block out the light of the sky entirely. Everyone drove with their lights on, and offices and stores were lit as for night. El Paso, Texas wasn't much better; instead of smog there was dust — the countryside blew horizontally and produced a gray amalgam of earth, sand and air. Our reason for leaving St. Louis and moving south was my asthma. El Paso's dust didn't hurt, but it didn't help either.

We arrived in Lamy in the middle of the night, and after checking into the tiny hacienda-type hotel next to the Santa Fe Railroad tracks, we went to bed. I had the great good fortune to have a nice little room of my own and, tired from the journey, I slept immediately.

Then something happened that changed my life. I went to bed in one world and woke up in another. Awakening, I realized immediately that something radically different was going on. The room was flooded with light coming through the window. I leaped out of bed and saw a sun-drenched hill with piñons growing out of pulverized red granite soil sparkling in that incredible sunlight. Looking out, I saw that most beautiful, brilliant blue sky. I knew immediately that here was where I belonged.

Later that morning we took the train to Santa Fe and were soon ensconced at 213 Marcy Street, along with Maria and her two daughters whom we had brought with us from Juarez. The landscape, the town and the people entered me and I became a part of that scene. Actually I became addicted to the New Mexico landscape, an addiction that wasn't broken until I joined the army in World War II. In the intervening years I drove, walked, and rode on horseback,

Edward T. Hall

and photographed a significant portion of the northern half of New Mexico and Arizona.

To me the country has always been sacred. The Santa Fe and Albuquerque skies, now muddied with the smoke of power plants and automobile exhaust, have lost their crystal clear character. There are places, however, where the landscape retains much of its original character. Ghost Ranch is one of them.

David Scheinbaum and Janet Russek, two New Yorkers born like me in the urban United States and raised in an artificial environment where the only sky was up, also found themselves transformed in the presence of our Northern New Mexico landscapes and particularly Arthur Pack's Ghost Ranch. This project was initially driven by the desire to examine what it was about these great open spaces — 22,000 spectacular acres of land — that captured the imagination of O'Keeffe, John Marin, Ansel Adams and others including myself. In order to explain their own wonder, excitement and awe, they wanted to record, for those seeing it for the first time, what it meant to be transformed by a landscape.

As an anthropologist, long-time student of visual image and perception, and photographer, I began to discover additional important dimensions implicit in this project, such as the subtle influence of country, gender and ethnicity on photography. Looking at the prints, I also noticed that in spite of years of close association with each other, David's images were, with few exceptions, strikingly different than Janet's. I asked myself, Did the combination of the two views give a more complete understanding than just one? It seemed that it did.

The difference between mediocre and very good or memorable images has to do with how much information the photographer can cram into her/his images and how long it takes to release that information. Another way of saying this is to ask, How many times can one view an image and still see something new?

This leads me to another point I wish to make of relevance to this project: Contrary to popular knowledge, people can be and are programmed by visual images when and if the images really work the way they should. Programming takes time, however. The book which you hold in your hands is not just to be placed on a coffee table, but is to be used. Viewed often enough, and along with the text, if the viewer allows themselves to enter the images they can literally begin to see the country in a way that is akin to that of the photographer. They can actually (if they let themselves) see the

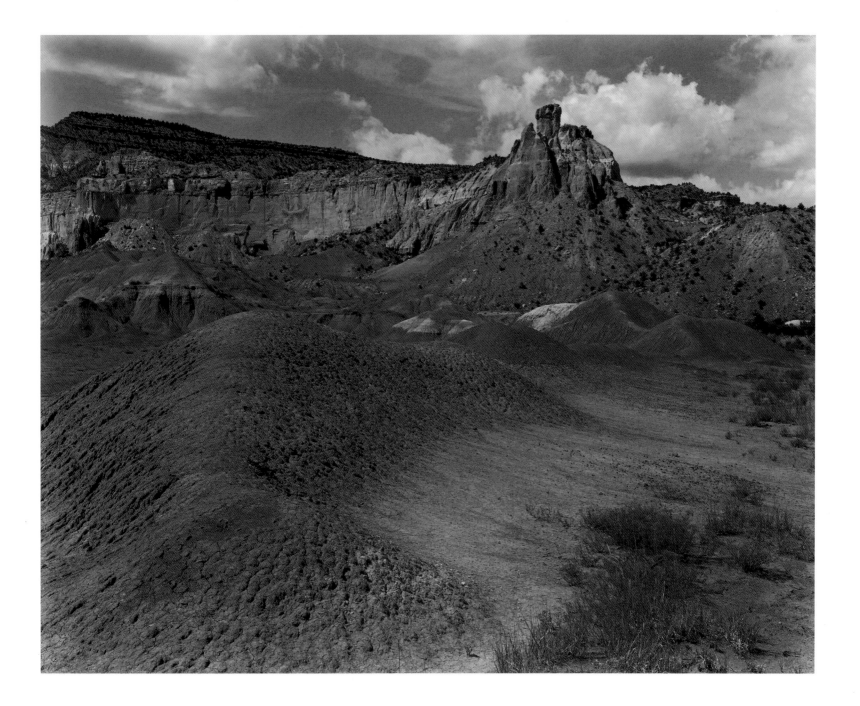

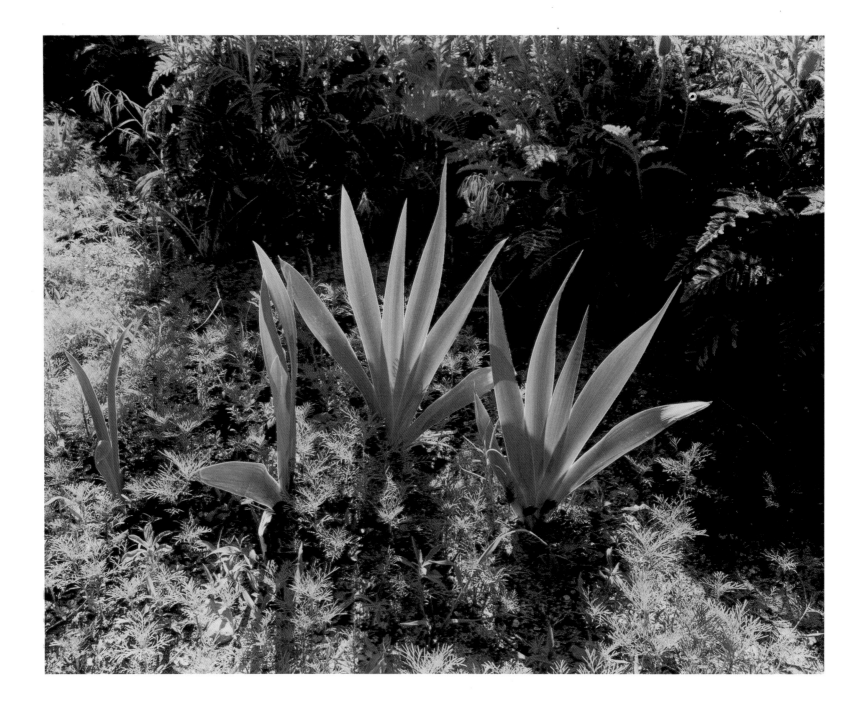

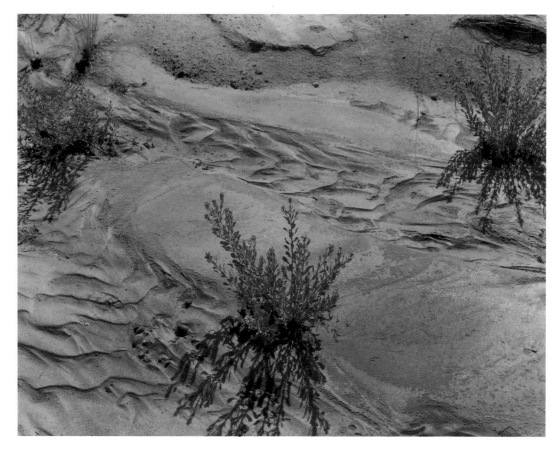

country (not just the photograph) in ways similar to the photographer.

Then there is the matter of the integration of text and photographs. Those who have thought about it know that the eye is a different organ than the mouth or the ear and that integrating printed text with visual images is far from easy. A text was needed, but who should write it? Clearly it could not be just anybody who could write. The idea of the creators of this volume was to provide different statements about the country. It was essential therefore to find individuals who could convey with words what it is like to grow up and live in an environment entirely different than that of most people.

Consistent with a tradition begun by Nancy Newhall, words and pictures could be combined in such a way as to achieve a deeper meaning than either alone. In the course of our conversations, the *Ghost Ranch* project evolved into a statement in three modes: its setting as seen for the first time — the child's image; as seen by the photography of a woman and a man closely bound to each other; and finally, not with the camera but with words, the spatial experience of the Tewa people. Like virtually all American Indians, the Tewa relate to the landscape in ways quite different than whites. To the Pueblo Indian, the landscape is organic, holistic, and tied to the people as an extension of the self, and visa versa. They do not experience themselves as apart, or separate, from the world in which they live.

Piedra Lumbre—A Brief History

The country of Ghost Ranch in the Piedra Lumbre of northern New Mexico has been wrapped in myth and mystery for thousands of years. In modern times, the region, also called the Chama Basin, has been most identified with American painter Georgia O'Keeffe who lived here more than half her life. O'Keeffe's paintings of the stark mesas and beautiful, multi-colored canyon lands of the *Piedra Lumbre* (Shining Stone) valley, and most especially of *Cerro Pedernal* (Flint Mountain), have made this landscape one of the most recognized in all the world.

Human fascination and admiration of Pedernal and the Piedra Lumbre predates O'Keeffe's by thousands of years. The pearly-gray and white flint that gave Pedernal its name was valued by people as early as 7,000 BC, when native tool makers journeyed from homes throughout the region to dig out the mountain's chert. In the origin myths of several Native American tribes, Pedernal holds a sacred position. Among the Jicarilla Apaches, it was Pedernal's angular head that Spider Woman first saw when she came onto earth. Changing Woman, one of the principal figures in the Navajo Origin Myth, may have been found wrapped in many colored lights on Pedernal's summit.

The Piedra Lumbre, or Chama Basin, stretches over one hundred square miles just east of the Continental Divide. The high desert plateau is crossed by the meandering course of the Chama River as it flows southeast towards its convergence with the Rio Grande some thirty miles south near Española, New Mexico. The Piedra Lumbre's gentle *llaños* (plains) and mesas along the river gradually rise to become fractured red and gold sandstone canyon country. Sheer cliffs edge the basin where it abruptly meets the first sierras of the Jemez, Nacimiento and San Juan mountain ranges that border the Piedra Lumbre on three sides.

Since the days of the prehistoric flint gatherers, the Chama Basin and river valley provided a natural corridor for foot and later horse travelers moving between central and northwestern New Mexico. Although the region was familiar to these people, it was not quickly, or easily, settled. The first inhabitants of the valley, probably ancestors of the Mesa Verde people, came to the region in the 11th century. They built numerous villages including Tsiping pueblo on a mesa east of Pedernal. These native people, ancestors of the modern Tewa, were accomplished farmers and hunters, potters, basket weavers and tool makers. They studied

Lesley Poling-Kempes

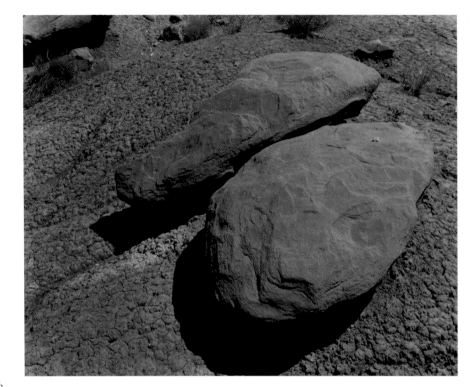

the stars and followed centuries old cultural and spiritual traditions.

The prehistoric pueblo people who made the Piedra Lumbre their home might have remained here into modern times, but another tribe of people entered the valley from the north. These newcomers, nomadic Athapaskan speakers the Spanish later called the Navajo Apaches, entered the region toward the end of the 13th century. Conflicts between these people and the sedentary pueblo dwellers lead to abandonment of the pueblos of the Chama Valley and the Piedra Lumbre by the 15th century when their inhabitants moved downstream into the pueblos of their relatives along the Rio Grande.

Although driven from their homes under Cerro Pedernal and along the valley of the Rio Chama, the Tewa of the Rio Grande maintained strong spiritual ties with the Piedra Lumbre region. Even knowing that they might confront their enemies, the Navajos, the Tewa continued to visit ancestral shrines, dig Pedernal's valued chert, and to collect *alumbre* (the rock alum used to dye cloth), in their former homeland.

The Navajos, who established seasonal hunting camps in the basin, would not claim the basin uncontested for long. By the 1600s, the Utes were pressing in on the Navajo's territory from the north and west. The Spanish, who under Oñate set down their flag in 1598 near San Juan Pueblo a mere thirty miles southeast of the Piedra Lumbre, also soon turned their conquistadorial eyes onto the fertile Chama River Valley and the lands below Pedernal. The Spanish called this country *la tierra de guerra*, the land of war. Throughout the 1600 and 1700s the valley of the remarkable, luminescent stone became a corridor between worlds — a warpath that connected the Spanish colonies growing downstream at Santa Cruz and Santa Fe with the territory of the nomadic tribes everywhere to the north and west of the Piedra Lumbre's mountainous perimeter.

The Piedra Lumbre was a fearful, unwelcoming place that resisted permanent Spanish habitation until the second half of the nineteenth

century. Even so, the Spanish soldiers venturing onto the frontier basin paused to reflect upon the regions remarkable beauty. Its first name, *Piedra Alumbre* , acknowledged its mineral wealth but the Spanish soon recognized the basin's visual attributes in its current name, *Piedra Lumbre* — fire rock, shining stone.

The first Spanish land grant on the Piedra Lumbre basin was granted in the 1730s to Jose de Reaño y Tagle, a Spaniard of considerable wealth and influence. Reaño built a sheep ranch on the llaños north of Pedernal, but kept his family within the relative safety of the Villa de Santa Fe. The Vega del Reaño on Cañones Creek was maintained by Geńizaros, detribalized Native Americans who were given Abiquiu Pueblo by the Spanish government in 1754. Ute and Navajo attacks on the Reaño's Geńizaro shepherds were fierce and frequent, but they remained at Reaño's ranch under Cerro Pedernal season after season, and his herds soon counted several thousand.

Reaño died in 1743. His widow traded his sheep operation to another Spanish family, the Montoyas. Within the next decade, several devastating Indian attacks drove the Montoyas off the Piedra Lumbre, and the ranch was used only sporadically in the 1750s and 60s. In 1766, a young lieutenant

of the Rio Arriba militia, Pedro Martín Serrano, requested that the valuable pasturelands of the Vega del Reaño, as well as all of the country that stretched across the Chama River to the far northern and western cliffs, be granted to him by the Spanish crown. The 49,000-acre Piedra Lumbre land grant was officially granted that same year and the Martin Serrano sheep empire became among the largest and most successful in the Spanish territory.

The United States seizure of the territory of New Mexico in 1846 had profound effects on the ownership and usage of the Piedra Lumbre land grant and the region in general. The Piedra Lumbre basin, like other large, basically unsettled stretches of New Mexico, was of great value to territorial land speculators. Although the region was not rich in timber or mineral resources, and the climate was too arid to promise any degree of agricultural development, the rock and cliff rimmed basin cut by the green swath of the Rio Chama was too large and beautiful a property for the new land barons and businessmen to ignore.

Thomas Catron and his circle of land speculators and lawyers, known as the Santa Fe Ring, began to acquire the Piedra Lumbre in the 1880s. At that time dozens of Martín Serrano heirs shared ownership of the grant land

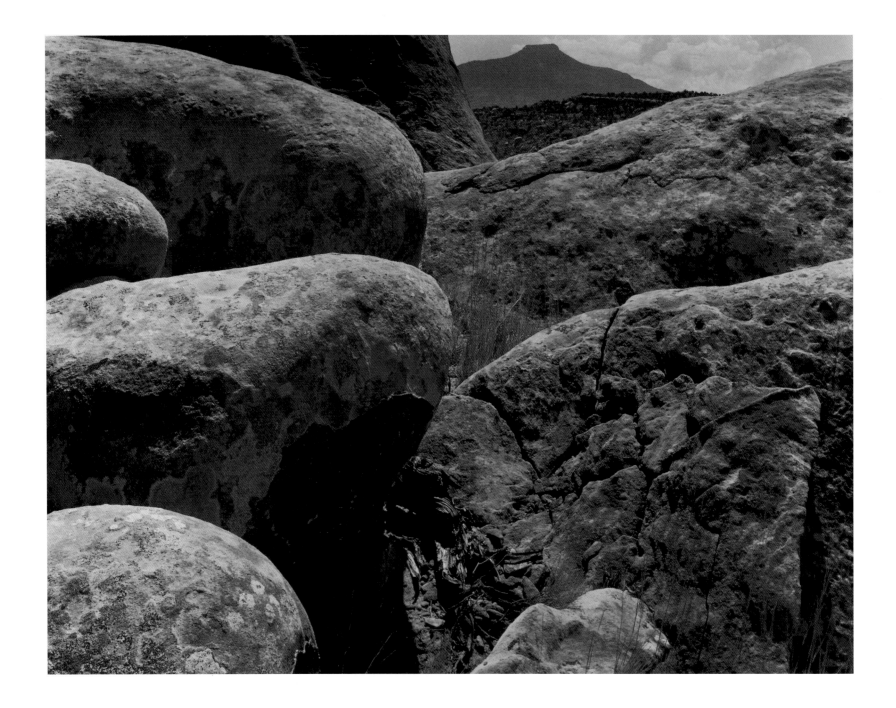

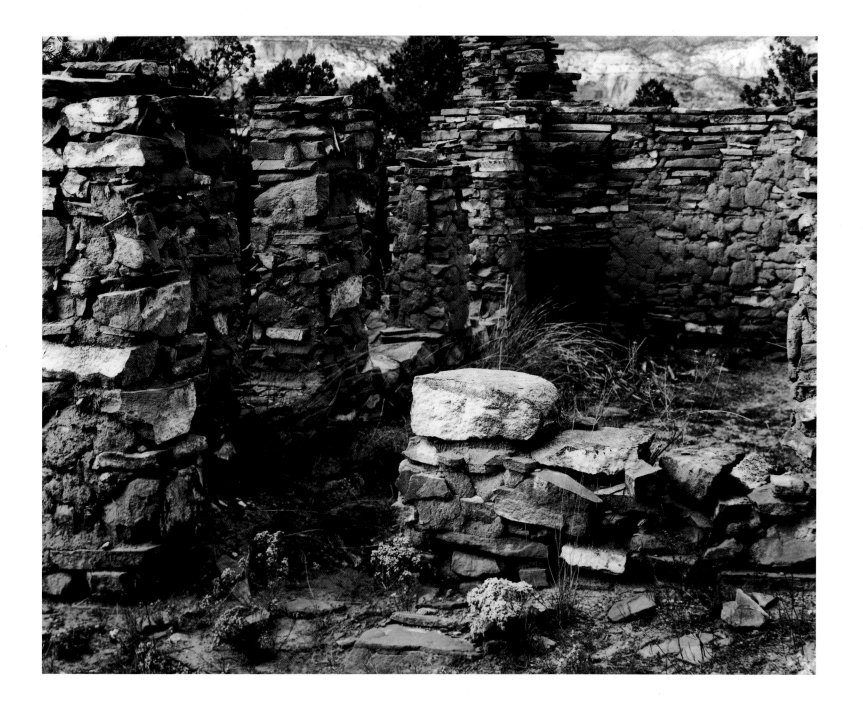

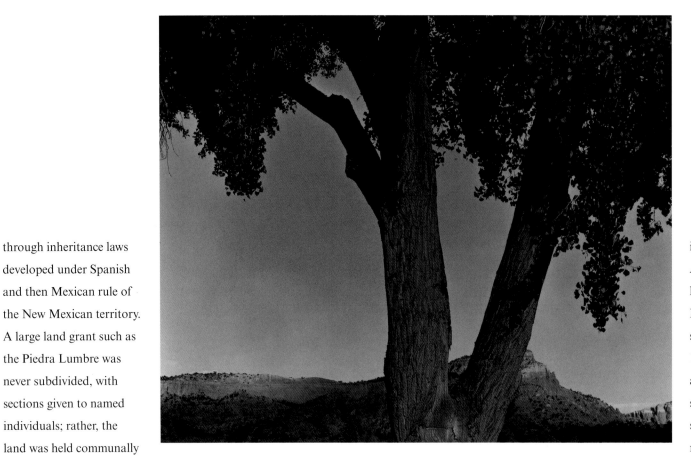

through inheritance laws developed under Spanish and then Mexican rule of the New Mexican territory. A large land grant such as the Piedra Lumbre was never subdivided, with sections given to named individuals; rather, the land was held communally among the family members and shared in its entirety over generations.

The confusion brought on by the American legal system imposed on the once Mexican/Spanish territory made it possible for Catron's ring of lawyers to purchase and eventually usurp nearly all rights to the Piedra Lumbre land grant. By 1893, after purchasing partial rights to the southern two thirds of the grant, Catron's cartel forced a court decision regarding legal ownership of the Piedra Lumbre grant. In 1894, a court settlement awarded the northern third of the grant to various Martín Serrano descendents. The southern two thirds was given to Catron's people, which included both Anglo-American and Hispanic land speculators. The Piedra Lumbre was surveyed and patented by 1902. Although Catron and his partners pursued several land development schemes, the beautiful, mythical basin below Pedernal never materialized into the successful business venture its new owners had visualized.

In the decades following Catron's acquisition of the Piedra Lumbre, and then his subsequent failures to develop the grant, the basin changed ownership many times. By the early 1900s, with the exception of lands in the northern third owned by several Anglo lawyers, the Piedra Lumbre was once again owned by local ranchers. Sheep camps dotted the llaños below Pedernal, and shepherds followed flocks into the sierras surrounding the basin as they had for more than a century. Although the small villages of

Cañones, Youngsville and Coyote maintained a subsistence-level hold on the basin's southern perimeter, the region of the luminescent rocks remained a sparsely settled frontier.

Settlement of the northern third of the Piedra Lumbre was hindered, in part, by its reputation among the local people as a place favored by *brujos* (witches). In particular, the canyon and cliff country of the Piedra Lumbre's northern edge was widely recognized as the home of various spirits whose nightly activities frightened shepherds with enough regularity to render its grazing lands unusable. Consequently, the well-watered lands of the Rito del Yeso in the basin's northeast corner were vacant and unclaimed in the 1890's when the two Archuleta brothers filed to homestead the spirit-infested canyon.

Although the grassy lands along the Yeso stream provided the Archuletas with prime agricultural lands, the brothers had no intention of becoming farmers. Instead, the Archuletas chose this corner of the Piedra Lumbre — bordered on three sides by sheer, impassable cliffs — to become the headquarters for their cattle rustling business. The Archuletas built an adobe house and corrals on a small, open plateau below the cliffs. Their cattle, herded in and out of the canyon at night, were held in the natural corral of rock. The brujos who frequented the canyon — said to include a flying cow that brought insanity and death to anyone who saw it, and a giant, child-eating snake that emerged at sundown below the gleaming cliffs — did not seem to have had much affect on the brothers. The stories of the Archuletas activities — which included murder of more than one unfortunate traveler who steered his horse upon their land — soon dominated the local lore and gave the region its name, *El Rancho de los Brujos*, the Ranch of the Witches.

Eventually the murder and mayhem turned onto the brothers themselves: one brother murdered the other when he refused to disclose the location of a buried jar of gold. Legend says the second brother either left the canyon, or was hung by local ranchers. Although the story of the buried gold brought fortune hunters to the old homestead, the Ranch of the Witches was considered haunted ground and for several decades no one settled this corner of the Piedra Lumbre.

In the late 1920s, Carol Stanley, a Bostonian woman, obtained ownership of the homestead. Old-timers claim that Stanley's former husband, Richard Pfaeffle, won title to the old Archuleta homestead in a poker game. In the Pfaeffle divorce settlement, Stanley was given the deed to

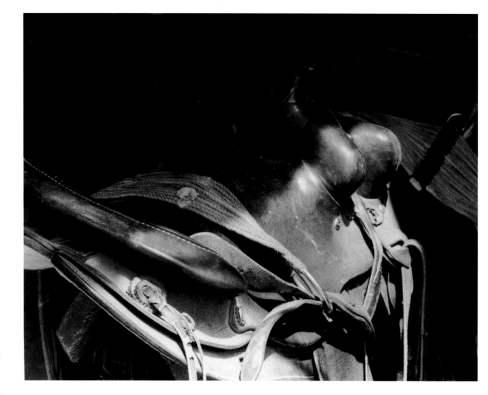

the Rito del Yeso area and ultimately obtained title to the northern one third of the Piedra Lumbre land grant. In 1932, Stanley moved into the Archuleta's adobe house below the fabled Hanging Tree where a rustler may have been hanged and attempted to tame the Ranch of the Witches with plans to make the old homestead, now called Ghost Ranch, into a guest ranch. She managed to build several guest cottages, a bunkhouse, and headquarters at Ghost Ranch before running out of money. By the late 1930s, Stanley had sold all of her interests in the Piedra Lumbre — more than 16,000 acres — to her friend, Arthur Pack.

Pack, a leader in national conservation efforts and editor and co-founder of *Nature* Magazine, had come to New Mexico from New Jersey. The Pack family's Ghost Ranch home, Rancho de los Burros, would later become the beloved home of painter Georgia O'Keeffe. In the next decade, Pack turned Ghost Ranch into a favorite vacation destination for his influential eastern friends and colleagues, including David McAlpin, Larry Rockefeller, Robert Wood Johnson and Ansel Adams. The frontier qualities of Ghost Ranch and the country of the Piedra Lumbre were exactly what Pack, O'Keeffe, and their friends came into the Southwest to find in the 1930s and 40s. The region was valued for the very characteristics that had made it so difficult to settle and "civilize" over the past several hundred years — its physical and cultural distance from modern America, and its climatic and topographic resistance to the taming hands of farmers and developers.

The use of Ghost Ranch as a guest ranch dwindled during World War II, during which it was used as an FBI-cleared vacation hideaway for the scientists working on the atomic bomb at nearby Los Alamos. After the war, knowing that the future of the lands of Ghost Ranch and the northern half of the Piedra Lumbre basin (Pack now owned 30,000 acres of the original land grant) were in his hands, Pack began to look for a suitable caretaker

who would continue to appreciate and protect the pristine, natural qualities of this marvelous country. In 1955, after much thought and a long search, Pack chose the Presbyterian Church to become the owner/caretaker of the lands of Ghost Ranch. The Presbyterians made the old guest ranch into a conference and educational center, but it has also continued Pack's three decades of soil conservation and range management programs that had kept the Piedra Lumbre's high desert lands healthy and thriving.

For more than forty years, the lands owned by the Ghost Ranch Conference Center have served as an example of successful human intervention with a landscape. The activities of the conference center are clustered in the area below the Rito del Yeso that once played host to stolen cattle. Livestock usage is carefully monitored so that the overgrazing problems experienced during the dust bowl of the 1930s will not return. Indigenous wildlife and native grasses continue to thrive on the remaining northern half of the Piedra Lumbre where development and subdivision of the land has not occurred.

Over the last ten years, the modern world has inched across the Chama basin, especially around the Abiquiu Dam and its reservoir built across the Chama River in the early 1960s. But the mythic mountain, Pedernal, is protected from human encroachment by National Forest and the lands of the Piedra Lumbre held by Ghost Ranch and several other private owners have been left in their primitive state. Those who value the last frontier tread softly across this beautiful, old country, and respectfully share the llaños, canyons and mesas with the animals and spirits who have long inhabited this sacred corner of the world.

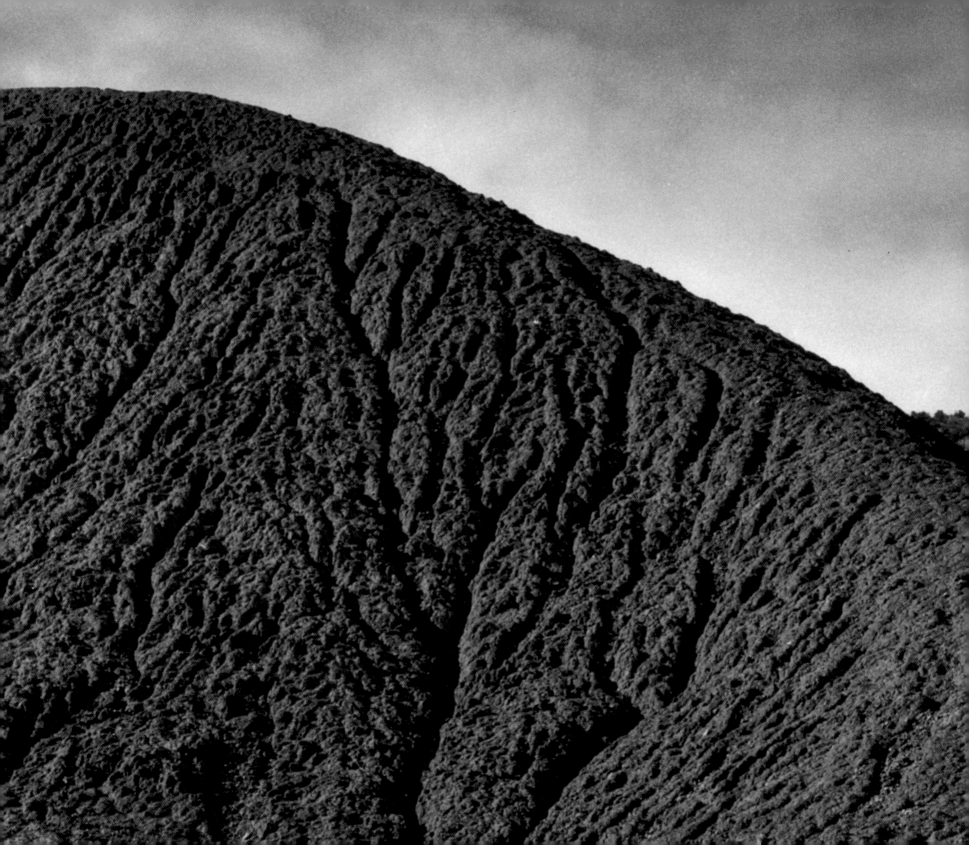

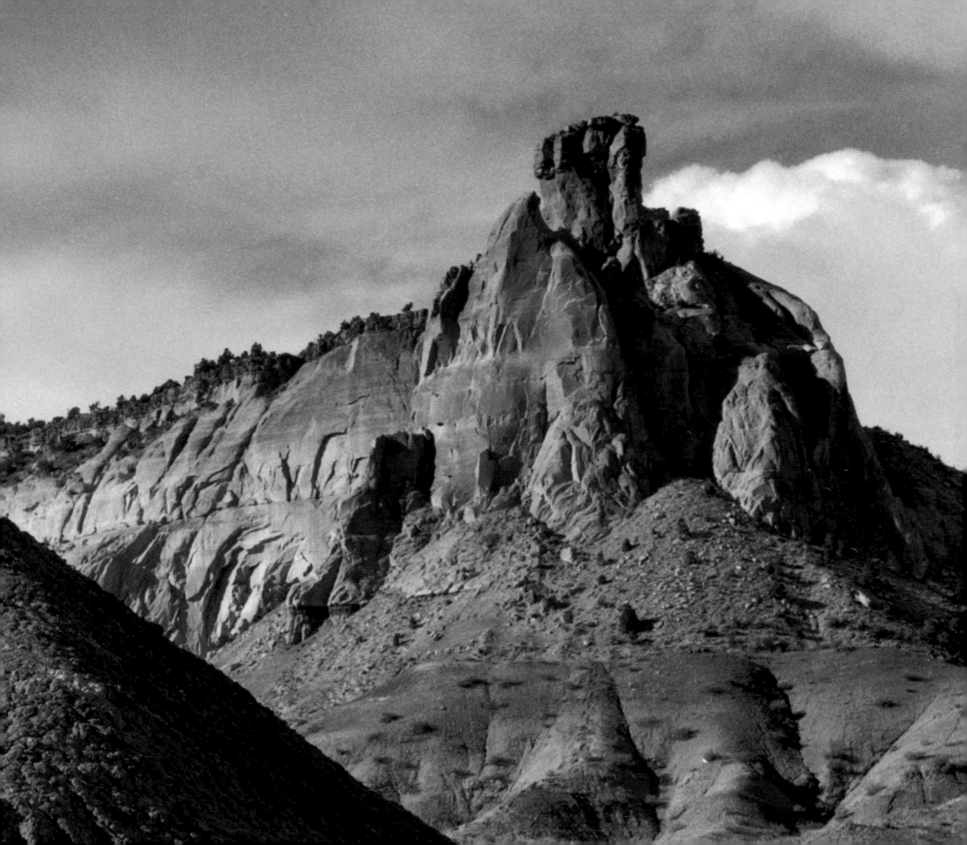

CENTER OF AN ANCIENT UNIVERSE

Ancient Pueblo people gathered and lived in beautiful places where invisible powers could be felt. The Ghost Ranch region is one of these places. It is visually striking and spiritually strong. It is also dotted with ancient Pueblo sites. There are still evidences of Pueblo clusters and single large villages on the mesas surrounding and defining the large open valley area. Old Pueblo sites are also found within the valleys and canyons.

The area had been occupied by Indian people for about a thousand years before the coming of the Europeans. The people who lived in the Ghost Ranch area during these pre-European times were the Anasazi or the ancestors of the Pueblo people. And, even more specifically, we know that from about 900 to 1450, the people who lived in this region were the ancestors of the Tewa Pueblo people, who now live along the middle Rio Grande River to the southeast.

These ancient people moved with great awareness of the mountains, hills and valleys, which provided both physical and spiritual sustenance. Wherever they went, they created villages which they knew were centers defined by the mountains and hills but

they also were symbolic centers, centers of the universe. The ancient people always lived at the center of the universe. And, even today, we, Pueblo and non-Pueblo, can feel that this Ghost Ranch region is the center of a universe.

For modern Tewa people, this Ghost Ranch valley is still viewed as a physical representation of the cosmos described in the age-old myths, stories, songs and prayers. These myths and stories describe the cosmos as a contained spherical unit with the upper half being the sky and the lower part being the earth. The sky is referred to as a basket in a Tewa song: "The blue flower basket for the sky it seems. It gleams and all is done." The sky is the male half of the cosmos which covers and protect the female earth bowl within which human and other life forms dwell. And, so it is in the Ghost Ranch area. The intense blue, cold sky made more so by the brilliant, warm multi-colors of the hills complement the lower earth-half to complete the spherical cosmos or world space within which life happens.

The lower half of the cosmos is likened to the terraced or serrated ceremonial clay bowl of the Tewa Pueblos by modern Pueblo people. It is from within this earthen bowl, from within the feminine valley space, that the surrounding terraced hills and

Rina Swentzell

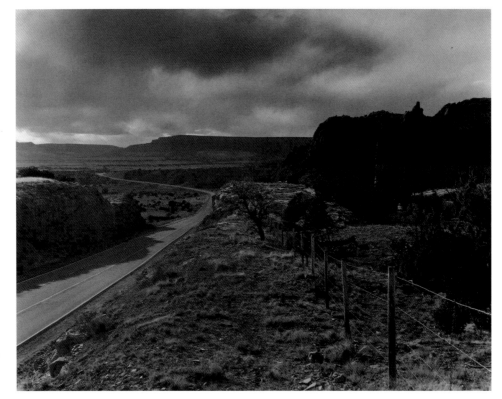

mountain forms are seen to connect with the male sky. In the Ghost Ranch area, this is an especially appropriate metaphor when one stands in the valley and sees the far hills and mountains all around the horizon describing the inside of this bowl-like lower half of the world.

four horizontal directions, North, East, South and West, are acknowledged as essential to a sense of place. In the Ghost Ranch area, the directions describe both a symbolic and actual valley place.

The Ghost Ranch valley, as a contained world space, has four entrances that flow between the hills and mountains into the outer world: the northeast passageway through which the Rita Canjilon flows, the northwest Rio Chama river canyon, the west narrow valley through which the Rio Puerco flows and the southeast Rio Chama canyon where the Chama River snakes toward the Rio Grande. These four openings raise the significance of the place for Pueblo people because of the number four. In the Pueblo emergence myth, the story of the beginning of existence for Pueblo people, the people lived and traveled through three worlds before finally reaching the fourth world, which is the present world. Within this present world space,

The sense of place within the Ghost Ranch region is exquisite and is reinforced by the interacting forms, colors and textures of the land, each strengthening the qualities of the other. The flat-topped mesas with their clay coatings of purple, orange, yellow, gray, and red contrast and accentuate, at once, the dramatic Cerro Pedernal peak where ancient Pueblo shrines are located and which are still visited by modern-day Tewa Pueblo people. It is on the mesas, however, that the ancient Pueblo people mostly chose to live. Here, they had the long-range views of the valley areas and here they could live in closer proximity to the sky where cosmic movement was visible in the billowing clouds.

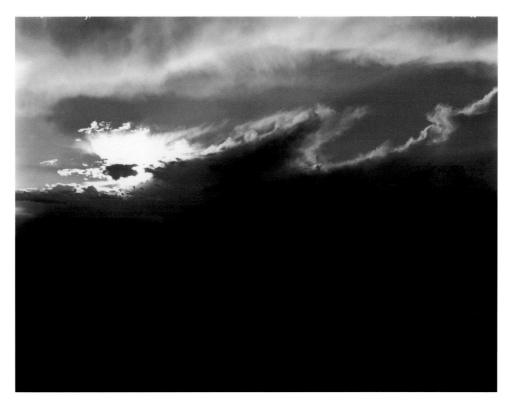

Movement is one of the themes of this place. It is a strong, spiritual place because there is movement. Rivers, streams, creeks flow into this place and out again. Thunderheads rise and move overhead. The wind swirls through the place twisting juniper trees in their rooted places. Crows caw alongside the canyon walls and over the mesa tops. The ancient Pueblo people moved into the area from places like Mesa Verde and Chaco Canyon. They created places to live on the mesas, valley floors and within the canyons for varying periods of time. Then, they moved on — like the water and clouds. By the time the Spanish arrived the area was abandoned and the sun, wind, and rain were working to erase the traces of these ancient people.

The place is still acknowledged as sacred by modern Pueblo people. They, as others, visit the place with prayers and thankfulness for the opportunity to share in the strength of a place where bleached bones, gnarled trees, mystical peaks and brilliant stars create a powerful wholeness.

All senses become acute as the colors of the place quietly vibrate. Birds and wind move over the crusty earth. The smell of raindrops mixes with pungent sage. Pueblo peoples' visits include taking the breath of the ancient people and their places into themselves. They take home colored clays to ceremonially paint their bodies and to decorate their pots and houses. It is all a way of becoming one with the beauty and soul of this center place.

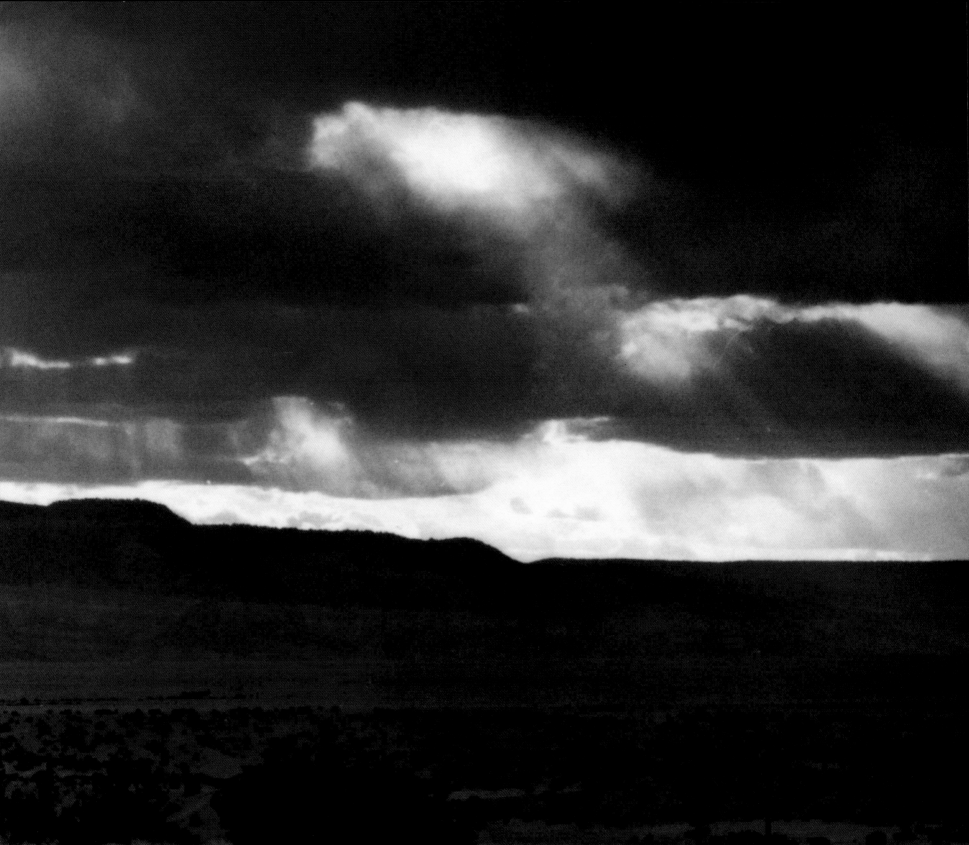

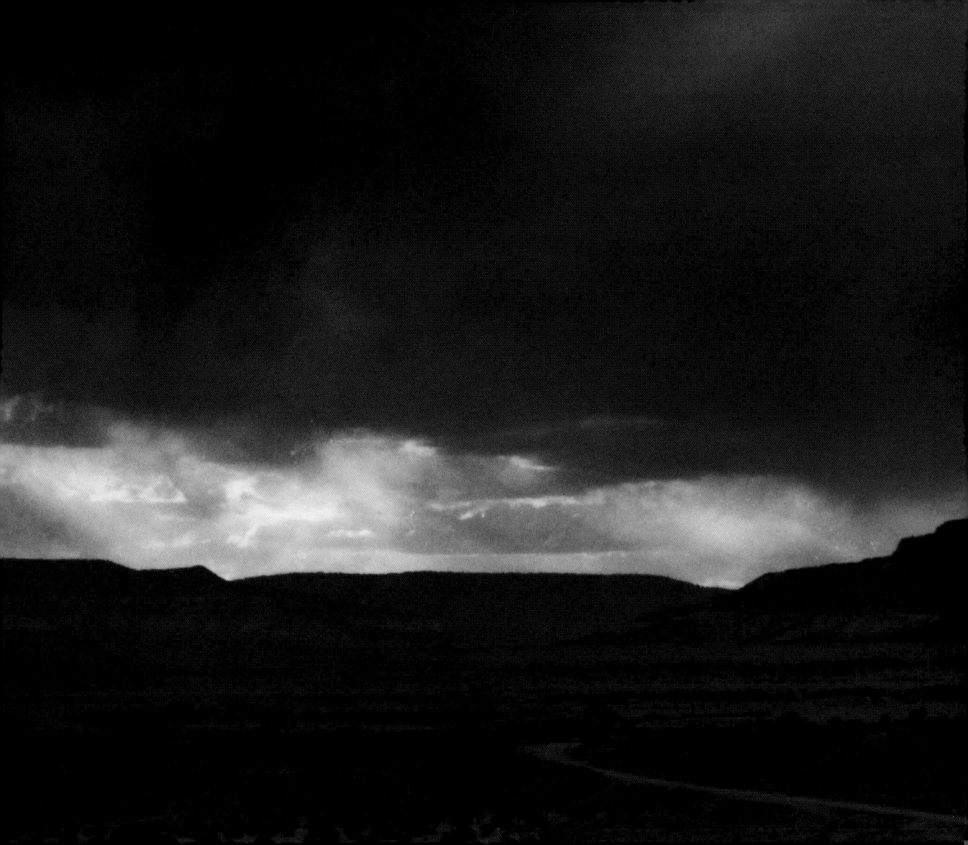

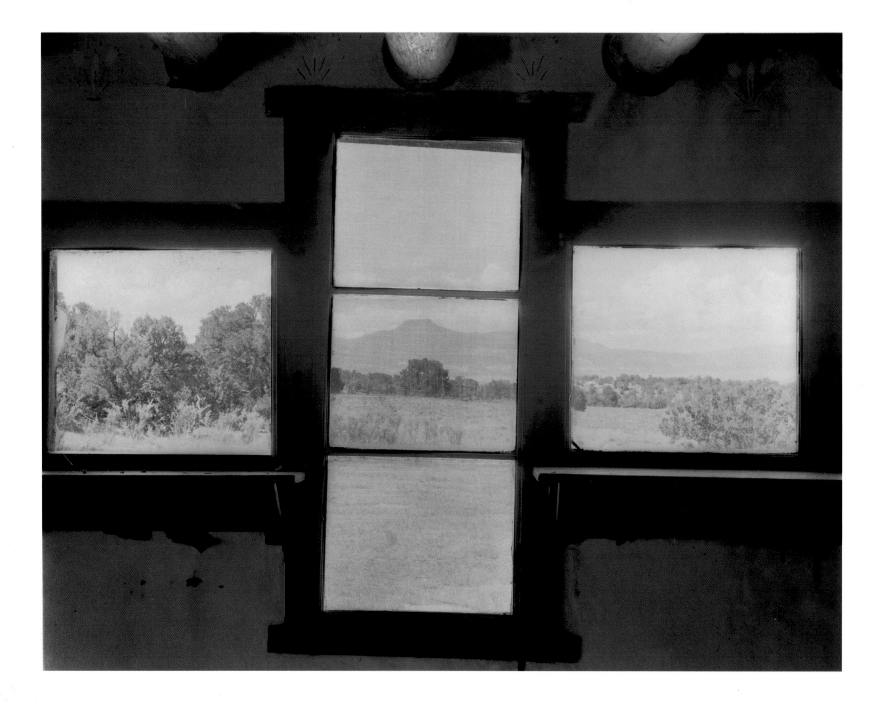

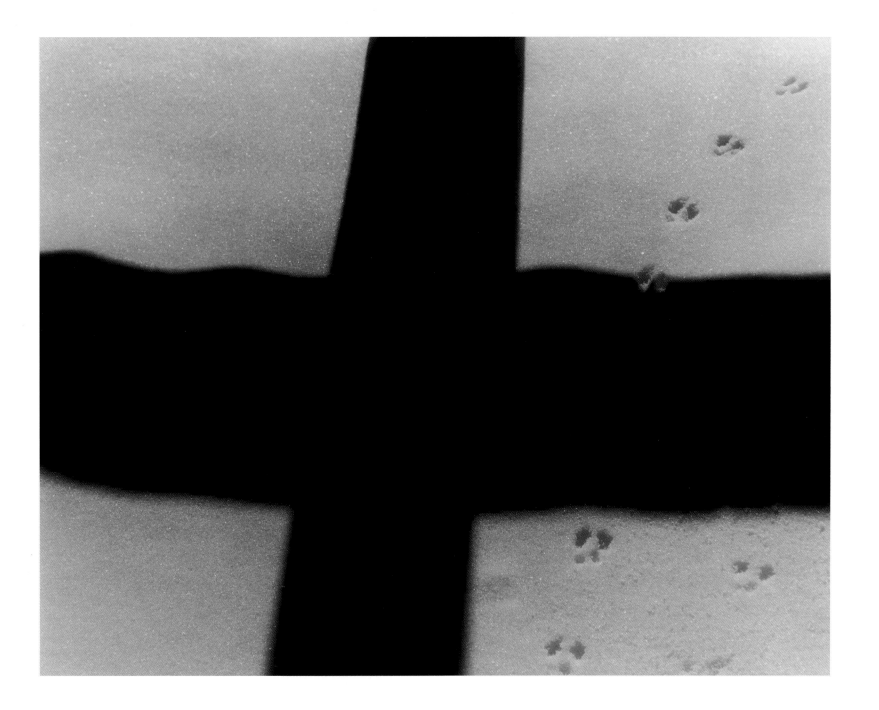

Burnt with the sun

Chafed with the wind

Soaked with the rain

Frozen with the cold and snow

Melting

Warmed by the sun

Caressed by the wind

Cooled by the rain

Frozen

Melting again

34 M A Y 2 6 , 1 9 9 1

Zachary is sleeping on my lap in the car — the sun is hot and intense. We have been out in the wind and sun for hours and our skin is crying for relief. Our skin is harshly dry, covered with a fine red powder of earth and slightly sun burnt. I am painfully aware of my skin, even as I write. I am aware of a small feeling of parchment paper, instead of hands. I am looking out the window at the earth's surface, thinking about its relation to the earth, being the earth's skin. How must it feel in the sun and wind all day, how it must welcome the wind for its relief from the overwhelming heat from the sun. As a child I would play a game; I would imagine myself as a rock or tree, a sedentary object or the earth's surface. I would lie down on the ground or rock and think what it would be like to be there, in that very same spot, forever, for an eternity, without being able to move or react. To be there forever. What patience, what endurance the earth has. How strong it is, and yet how hard it must be to be the earth, to accept whatever comes.

I am looking out over this beautiful red dirt, with small green plants growing out of it; arid, pock-marked, rocky, and so still. The earth accepts and gives us its beauty and questions. It is uncaring of man, yet it is our nurturer and teacher.

J A N E T R U S S E K

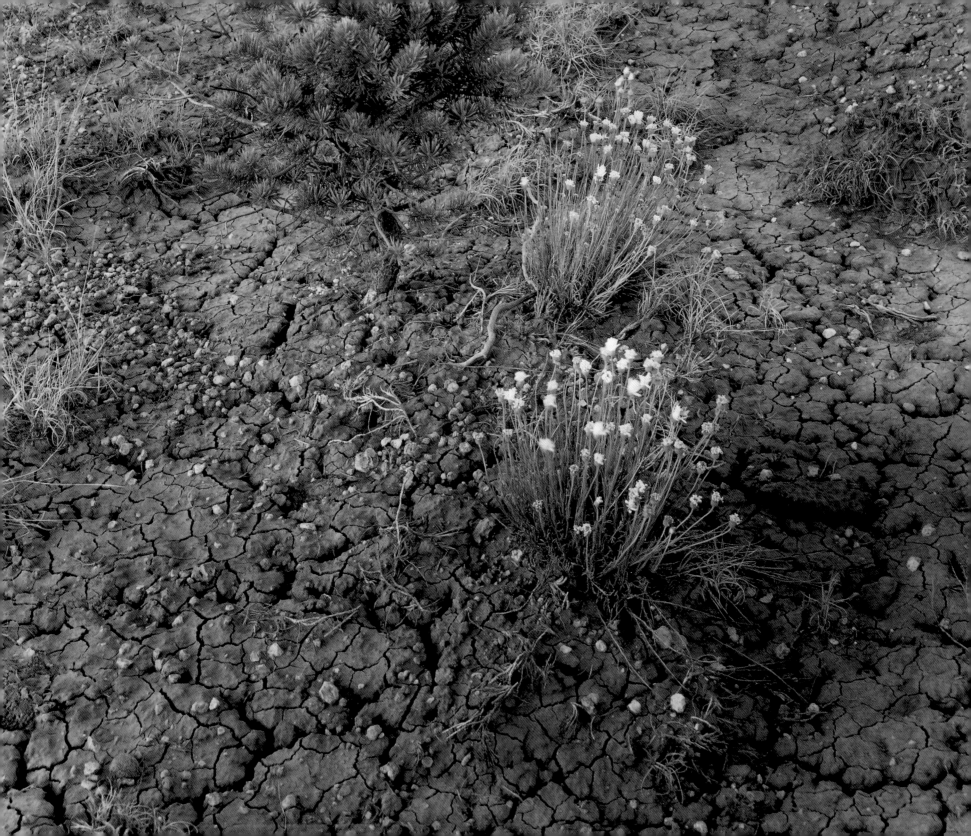

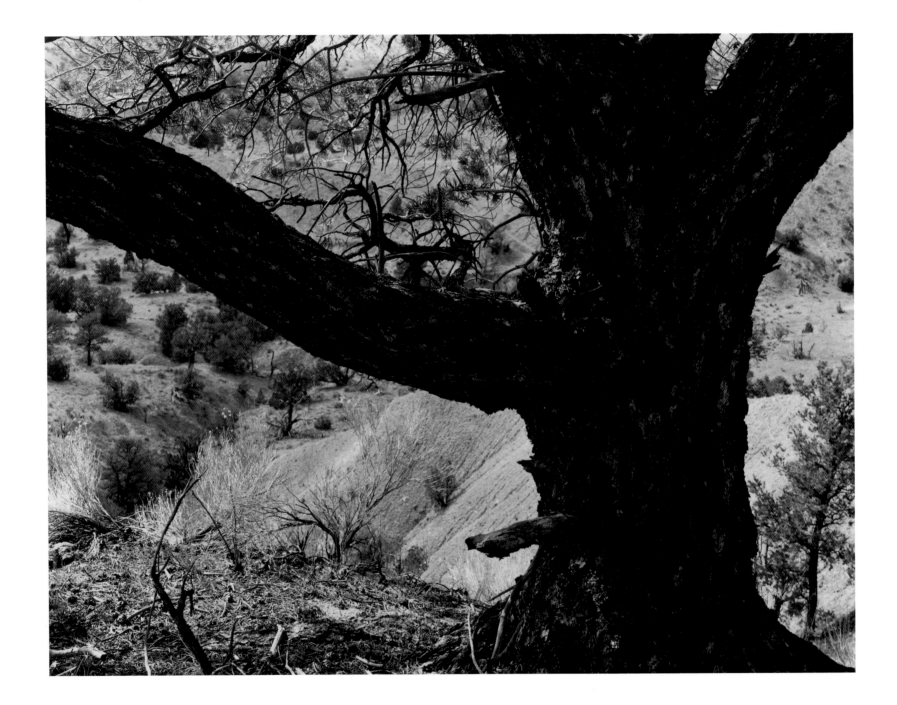

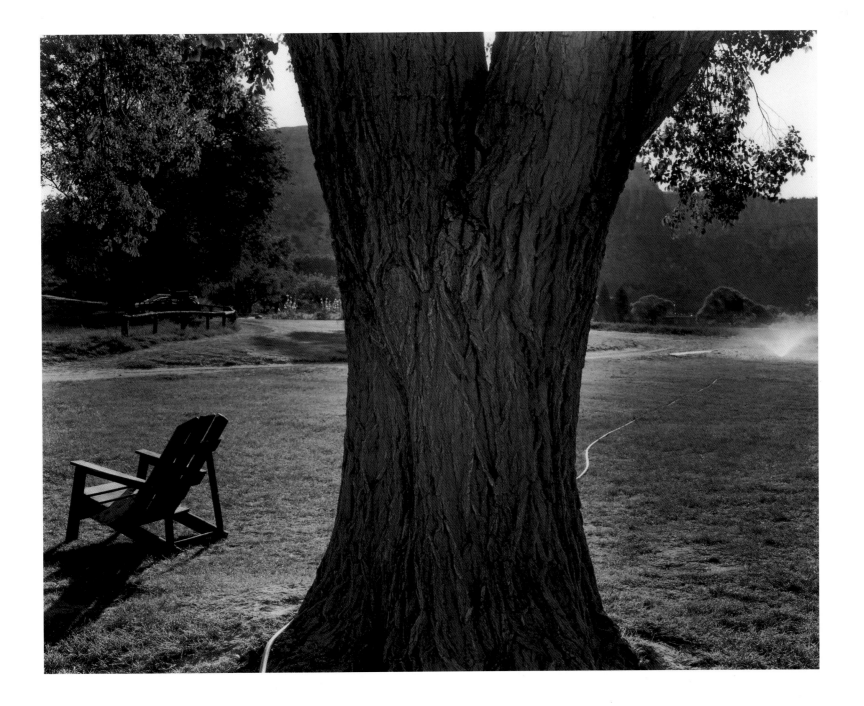

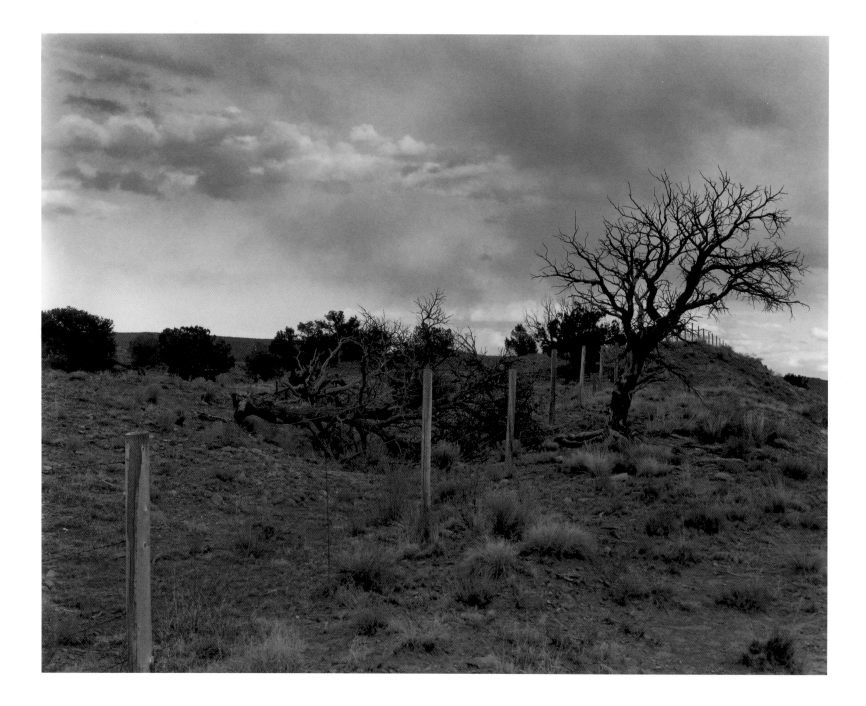

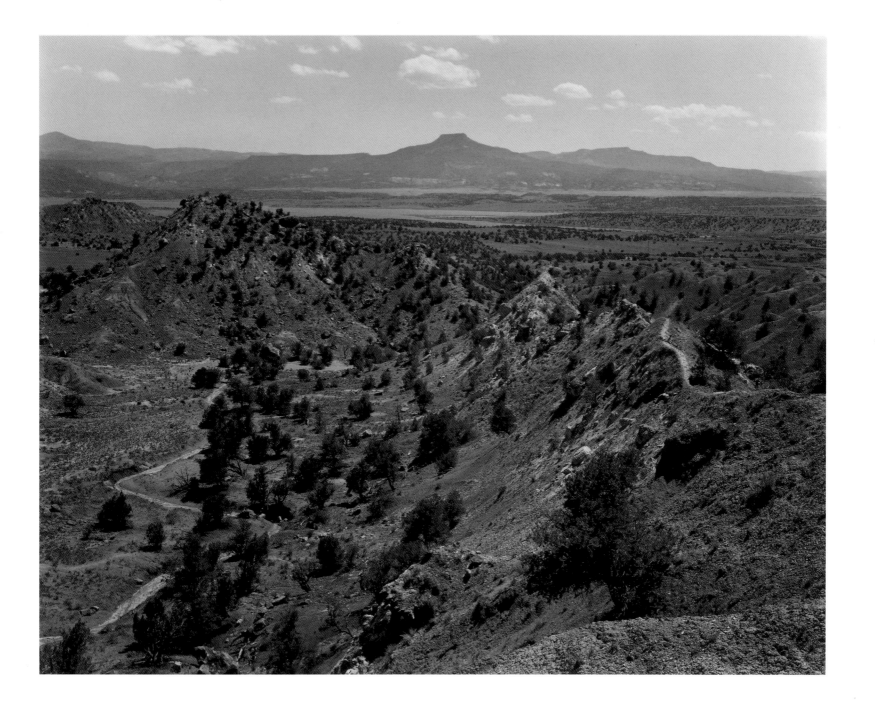

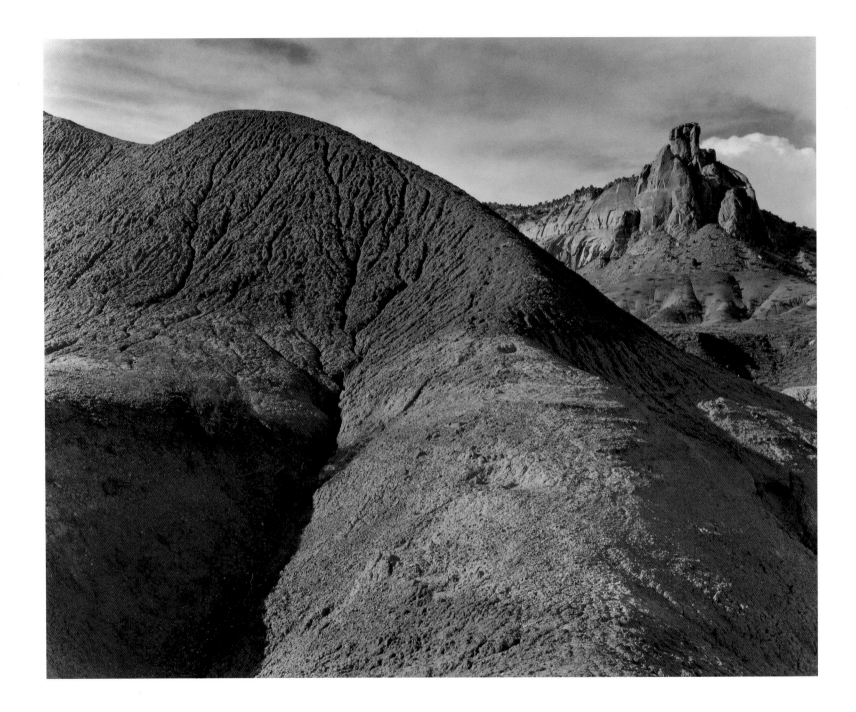

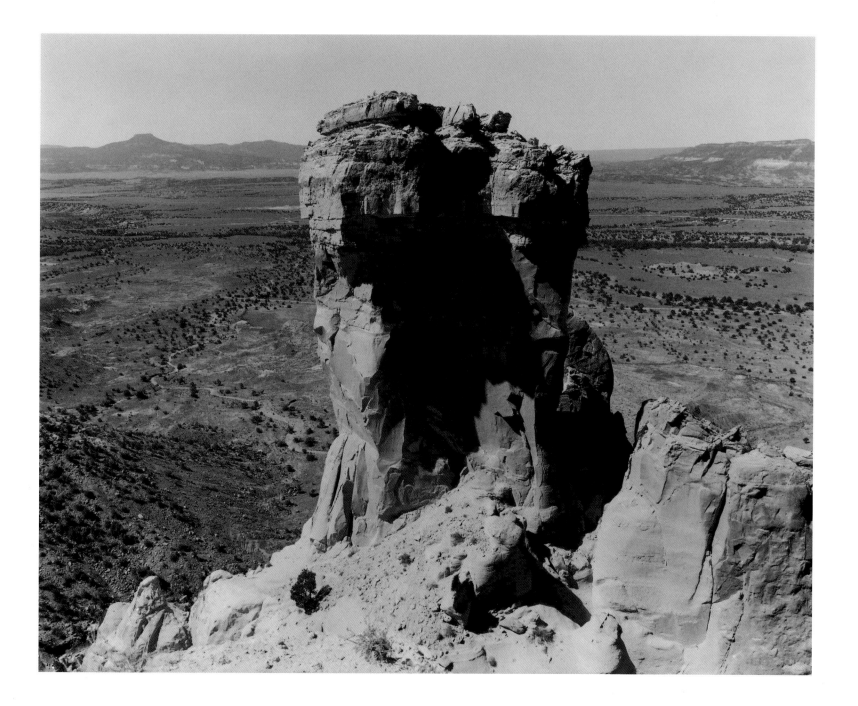

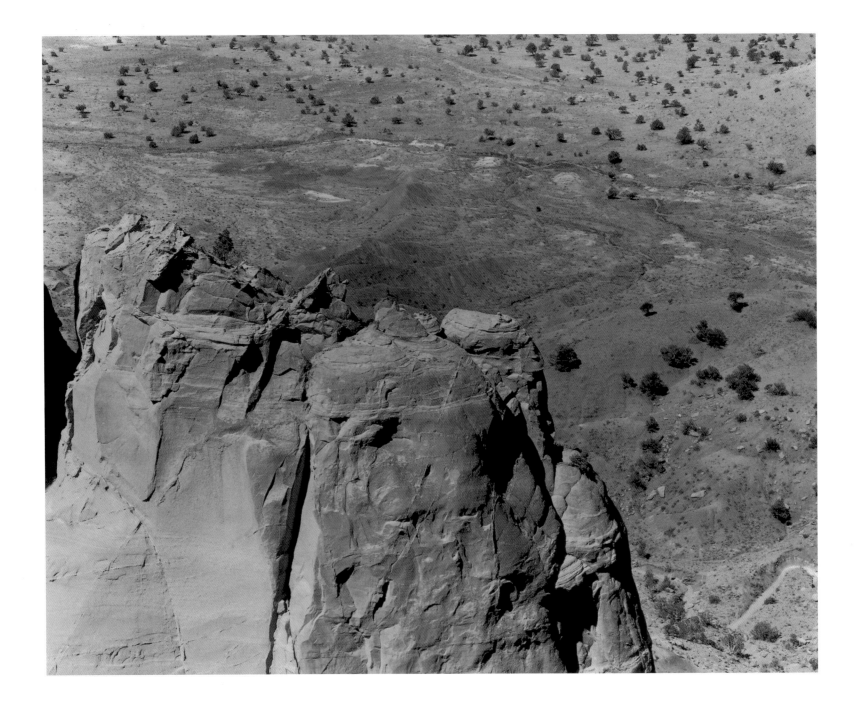

It is all very beautiful and magical here — a quality which can not be described. You have to live it and breathe it, let the sun bake it into you.

The skies and land are so enormous, and the detail so precise and exquisite that wherever you are you are isolated in a glowing world between the macro

and the micro, where everything is sidewise under you and over you, and the clocks stopped long ago. —Ansel Adams

44

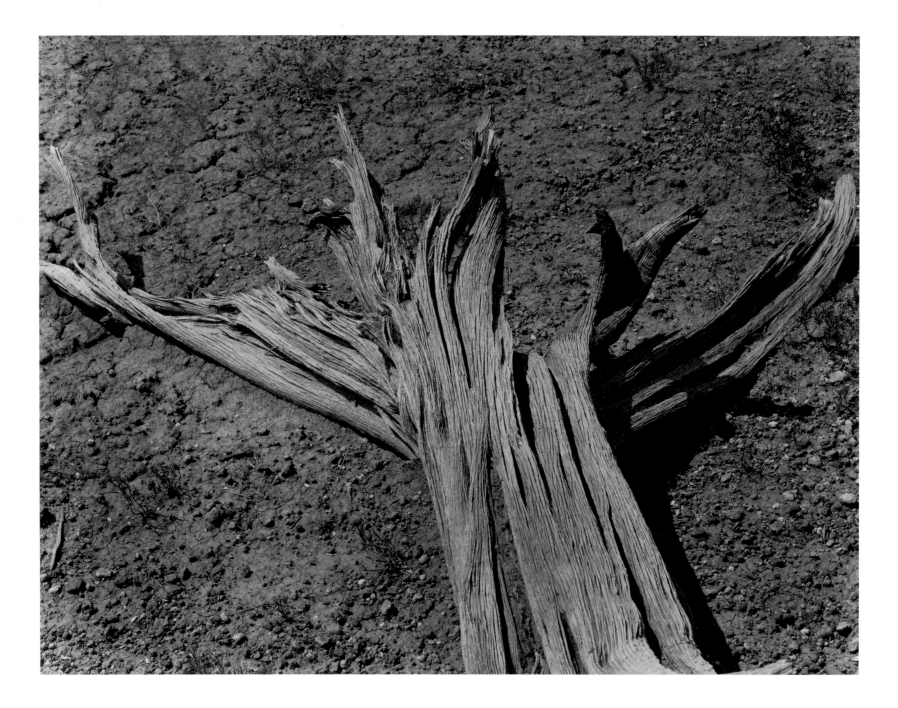

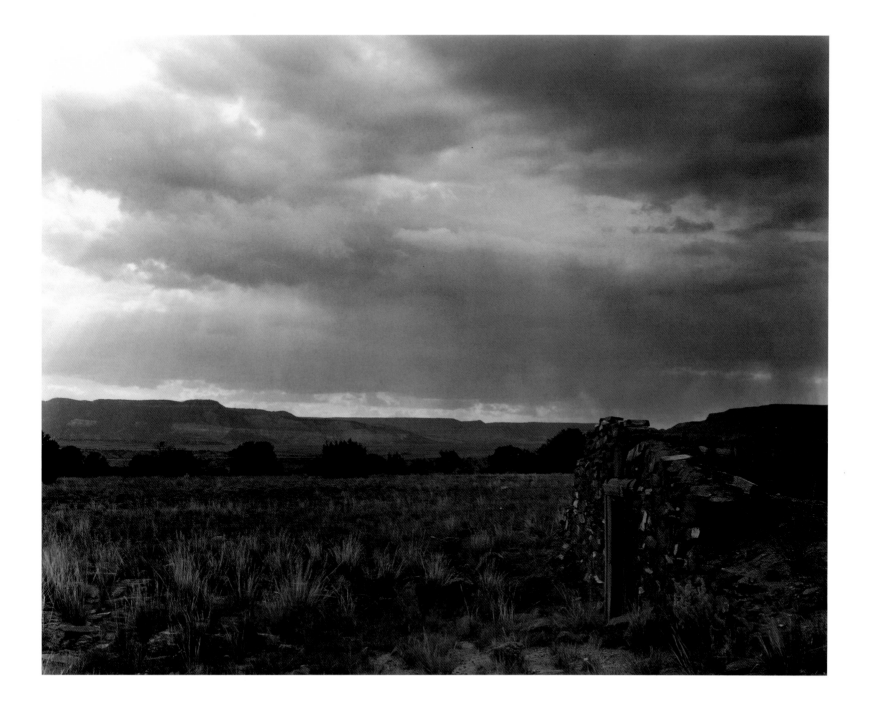

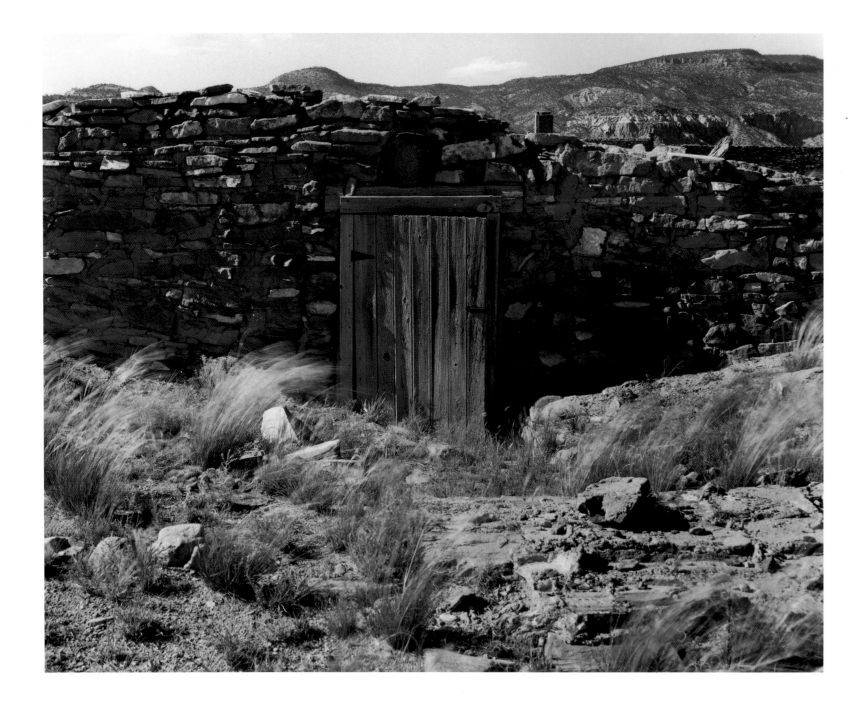

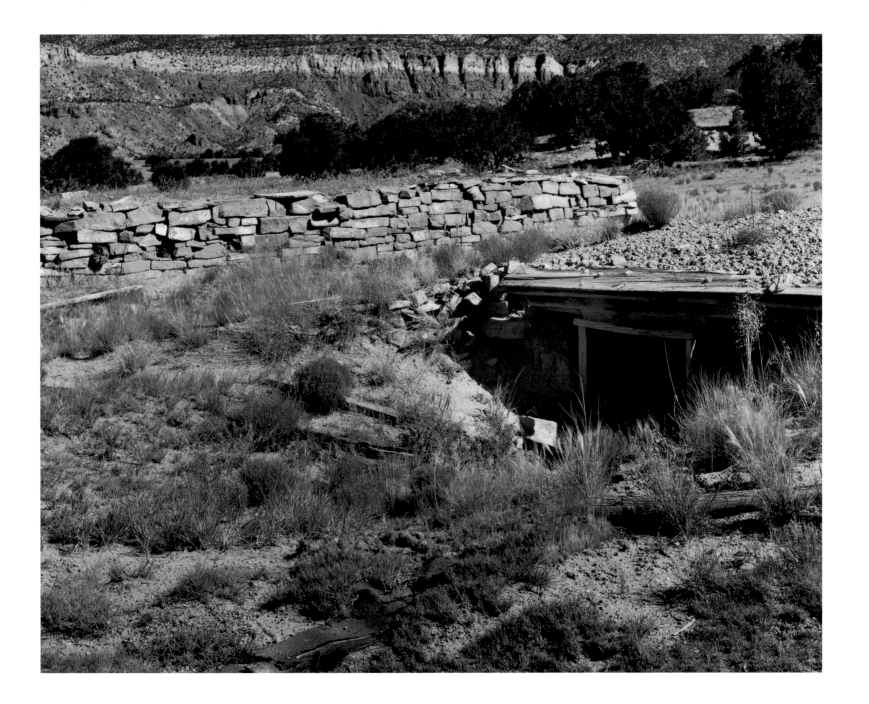

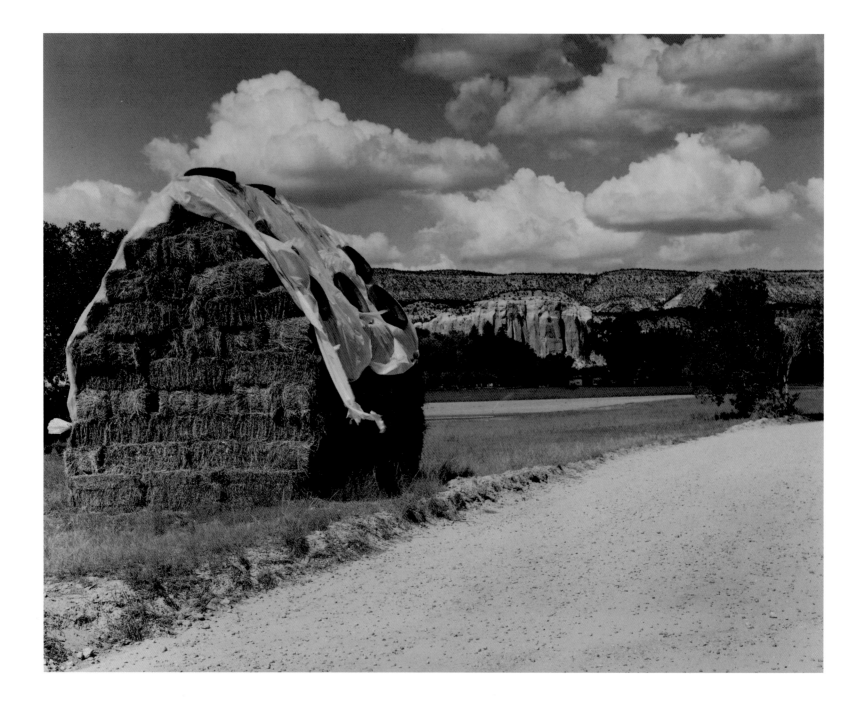

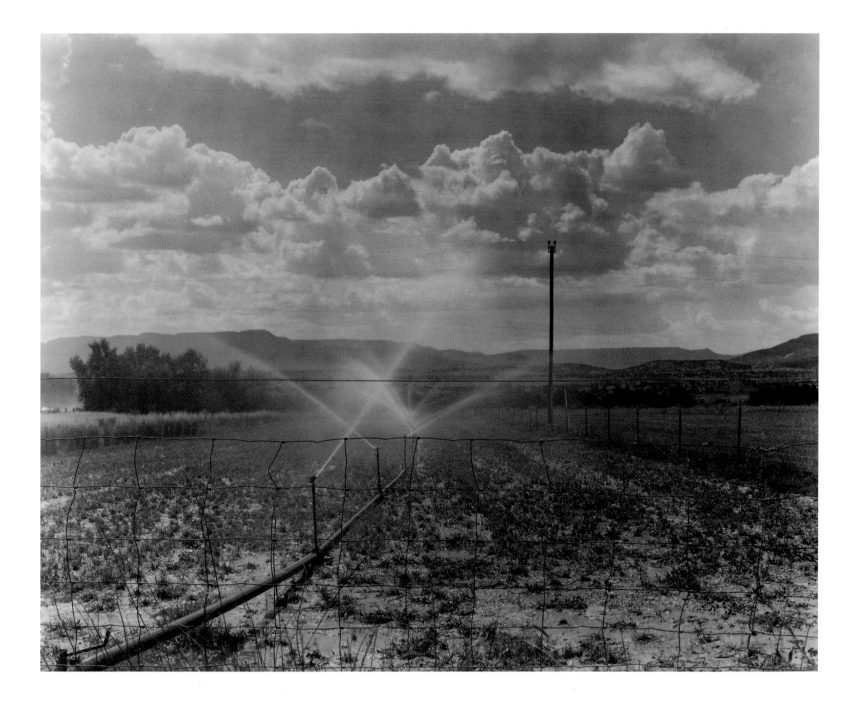

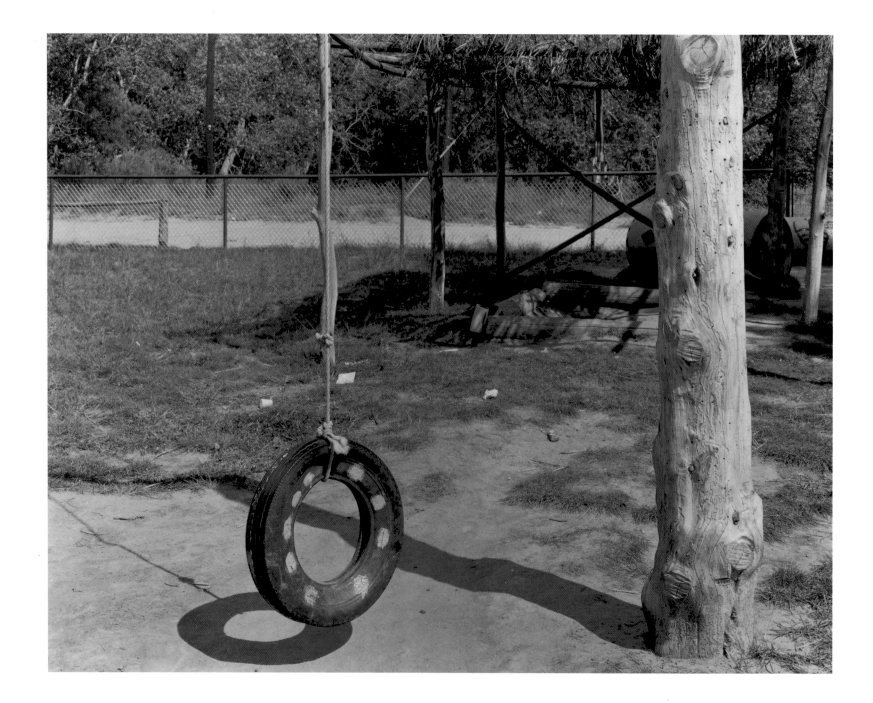

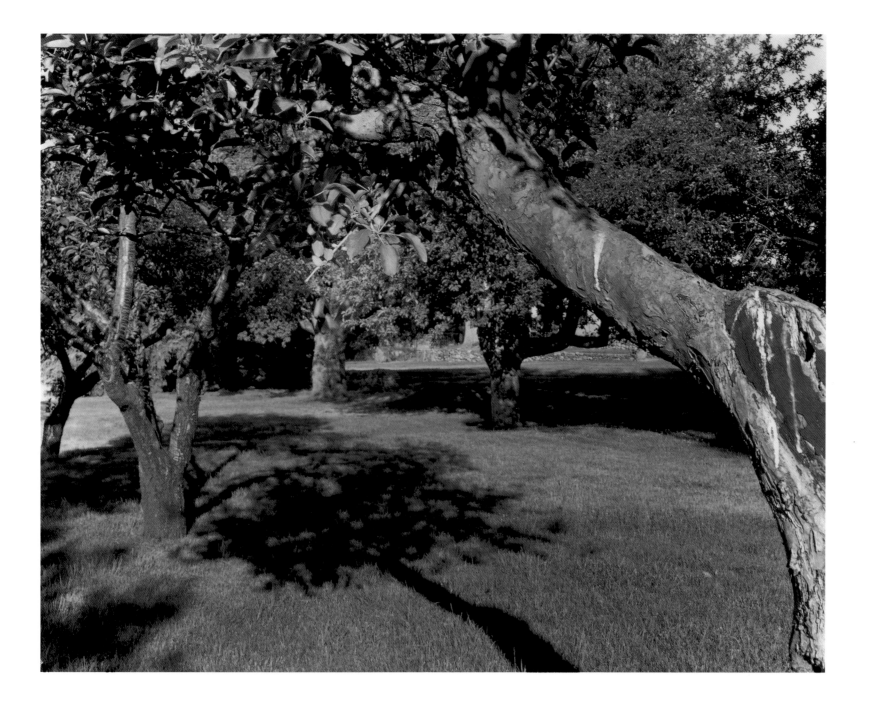

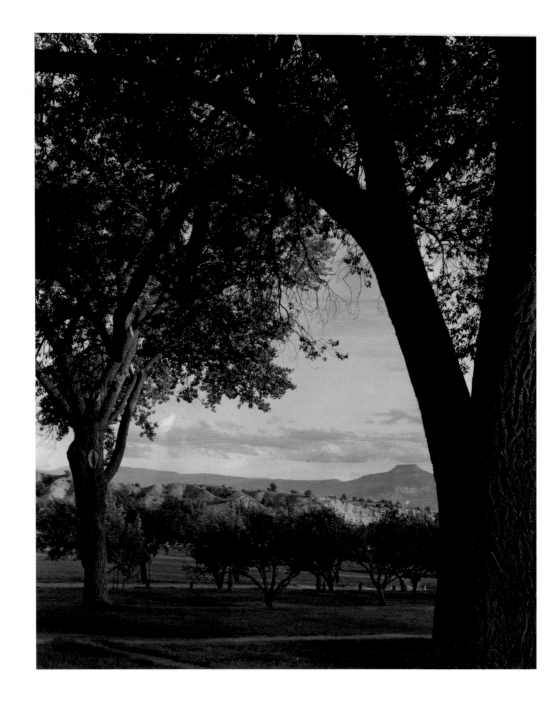

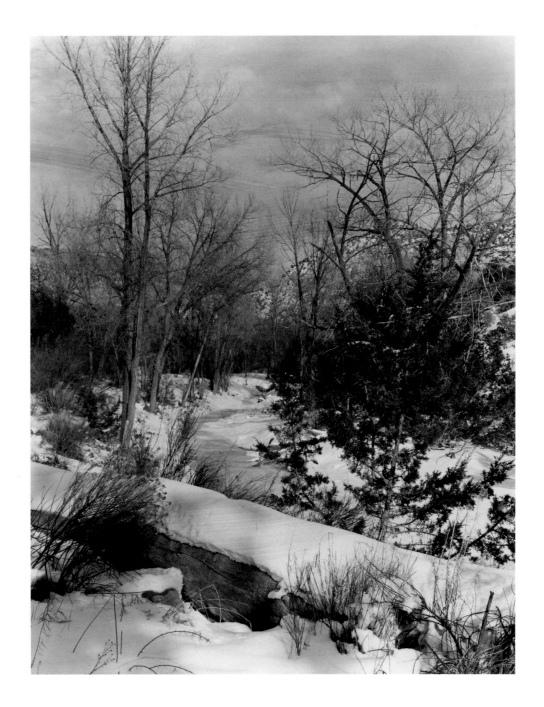

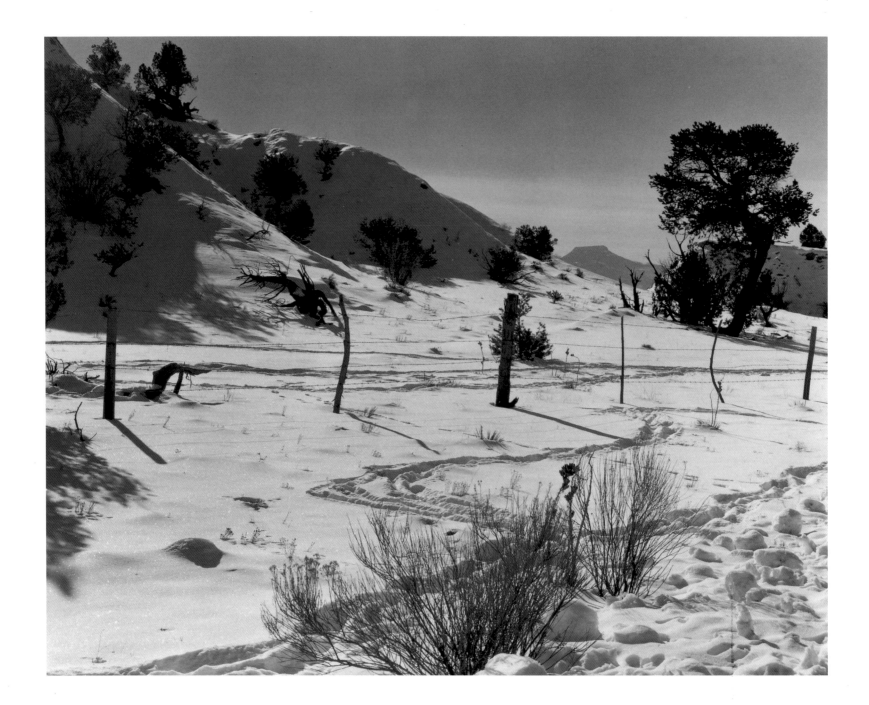

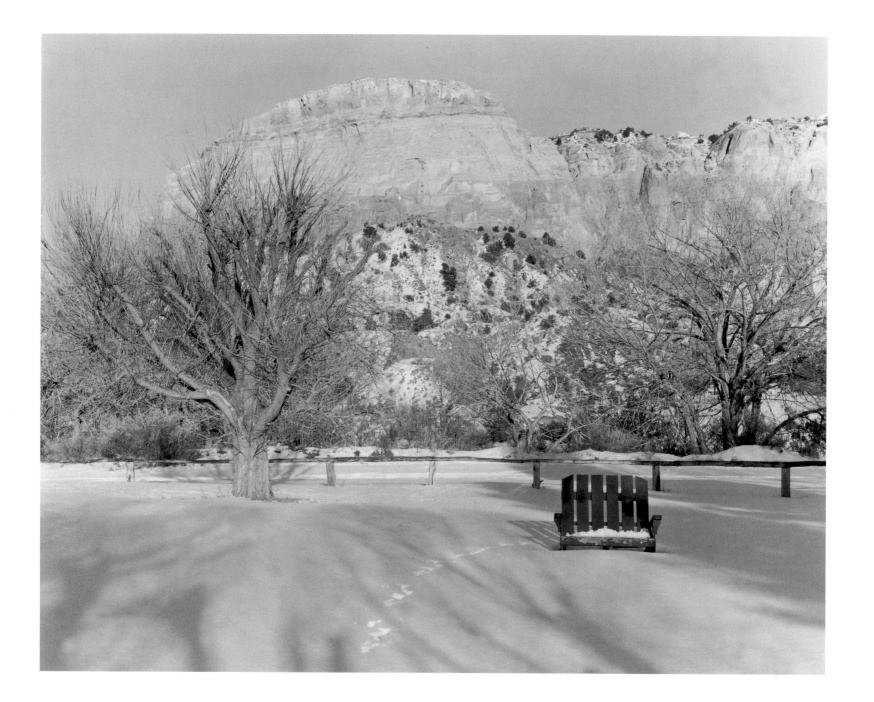

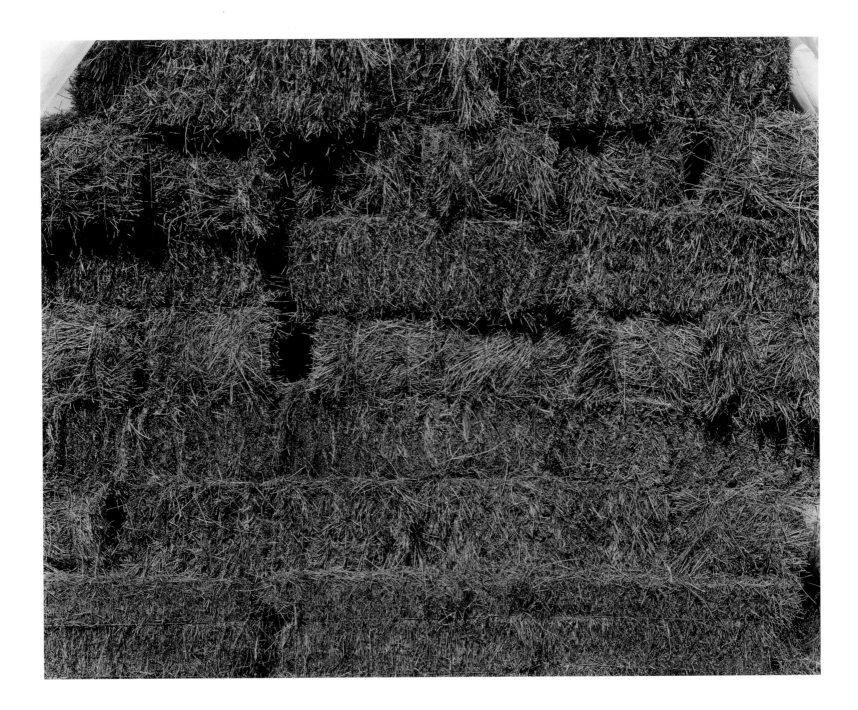

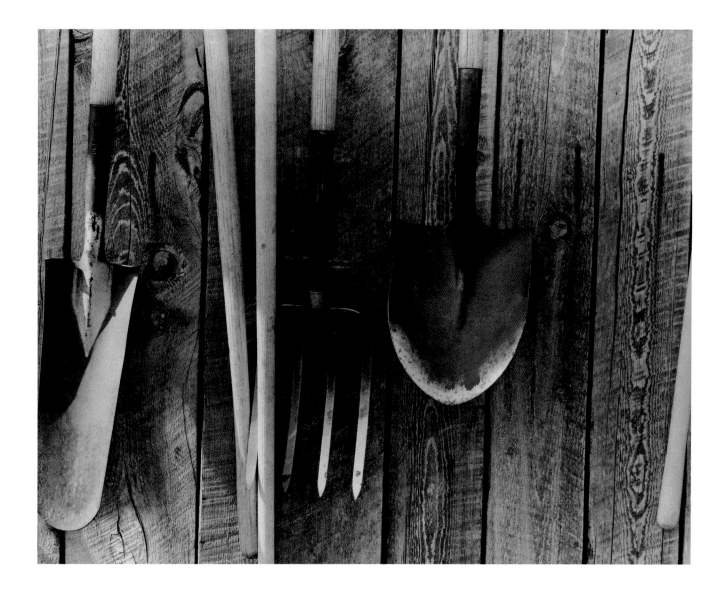

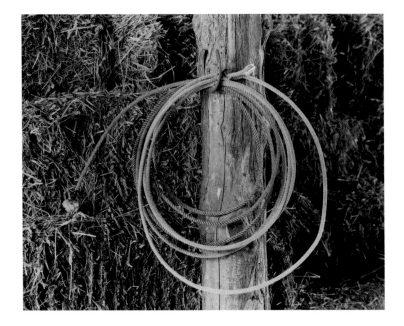

58

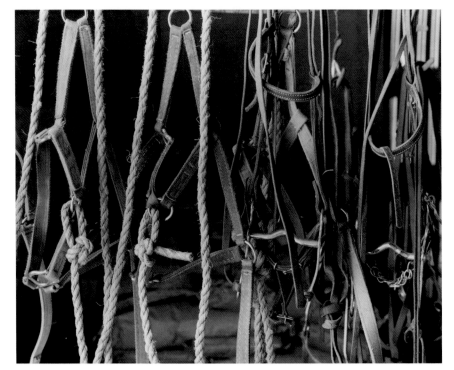

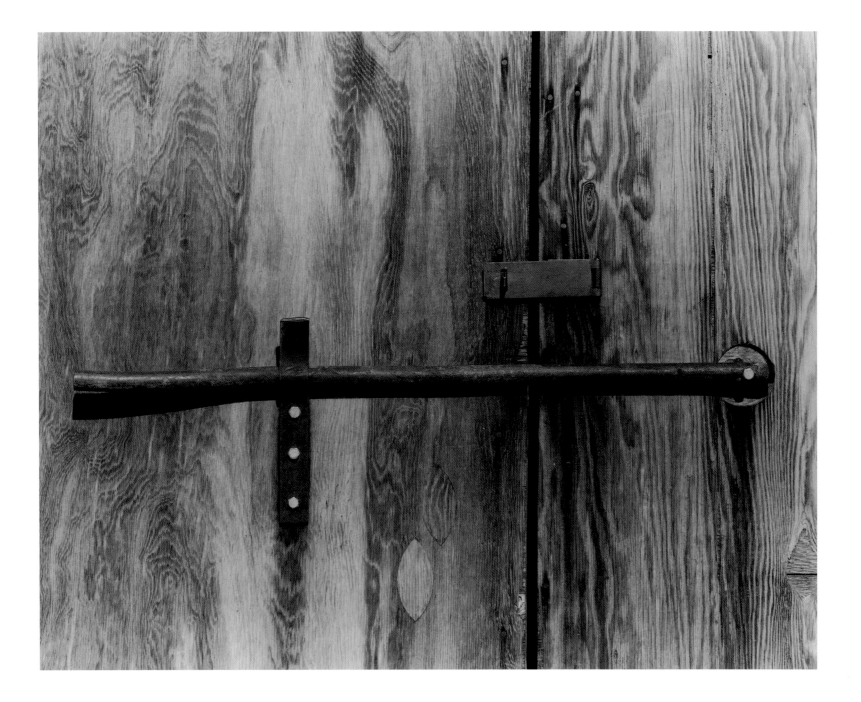

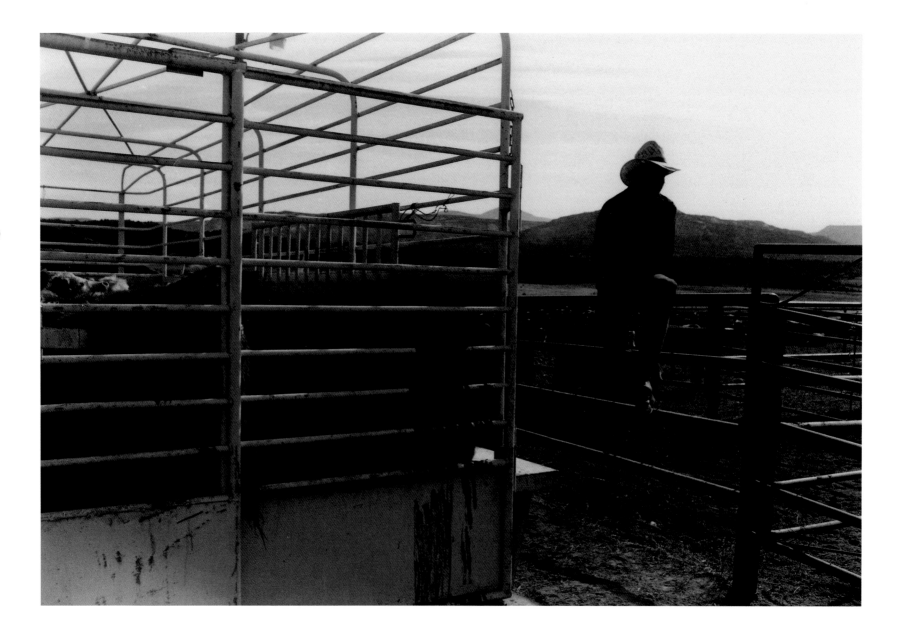

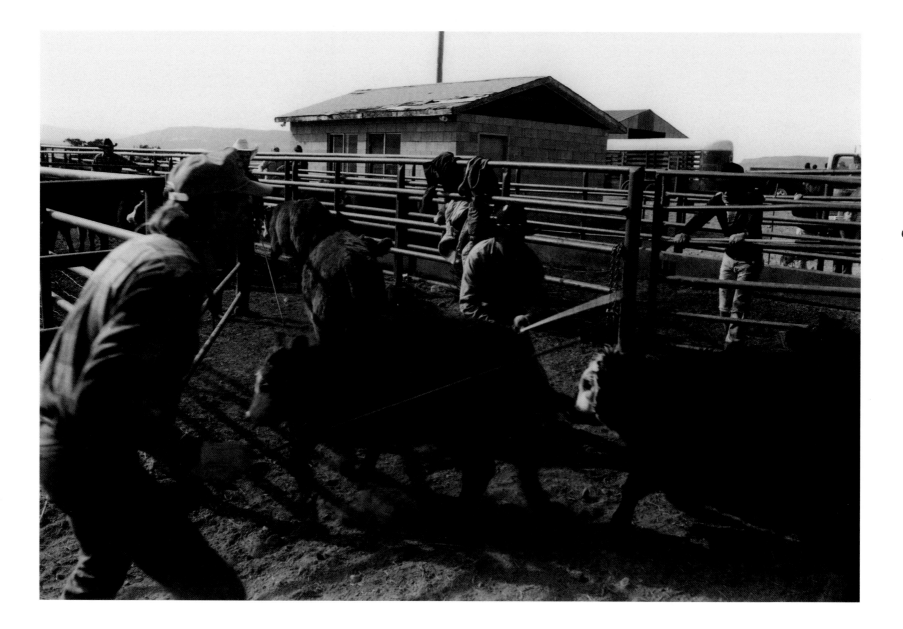

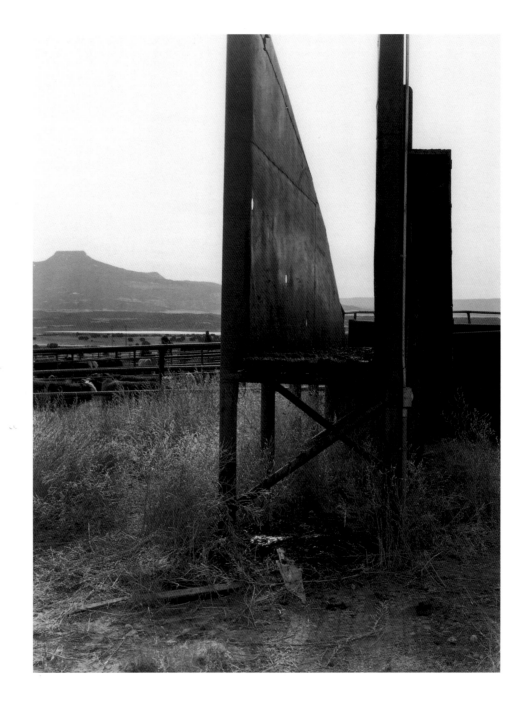

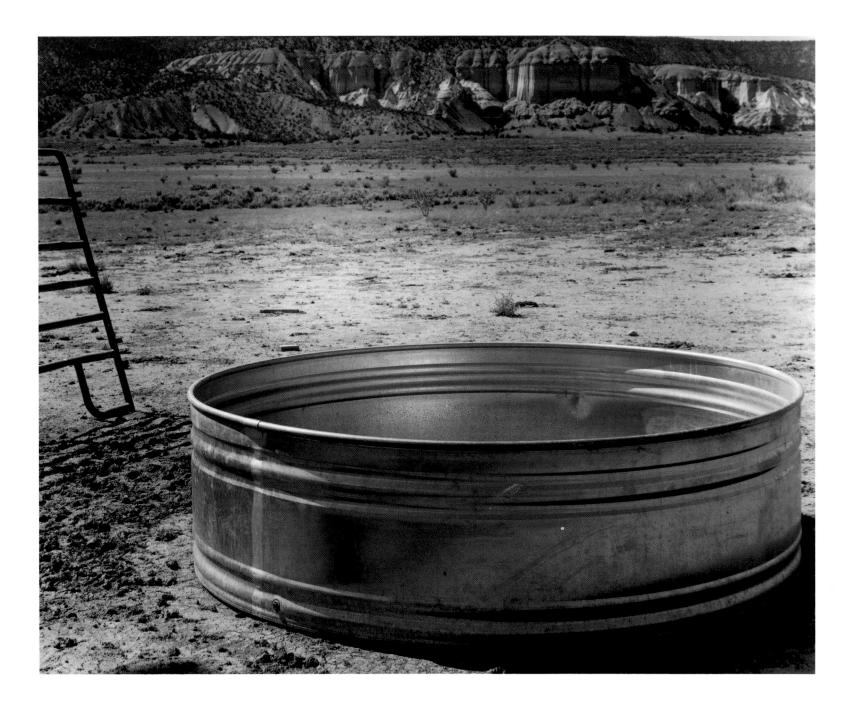

64 Here are the long heavy winds and the breathless calms on the tilted mesas where dust devils dance, whirling up into a wide pale sky. Here you have no rain when

all the earth cried for it, or quick downpours called cloudbursts for violence. A land of lost rivers, with little love in it; yet a land that once visited must be come

back to inevitably. If it were not so, there would be little told of it. —MARY AUSTIN

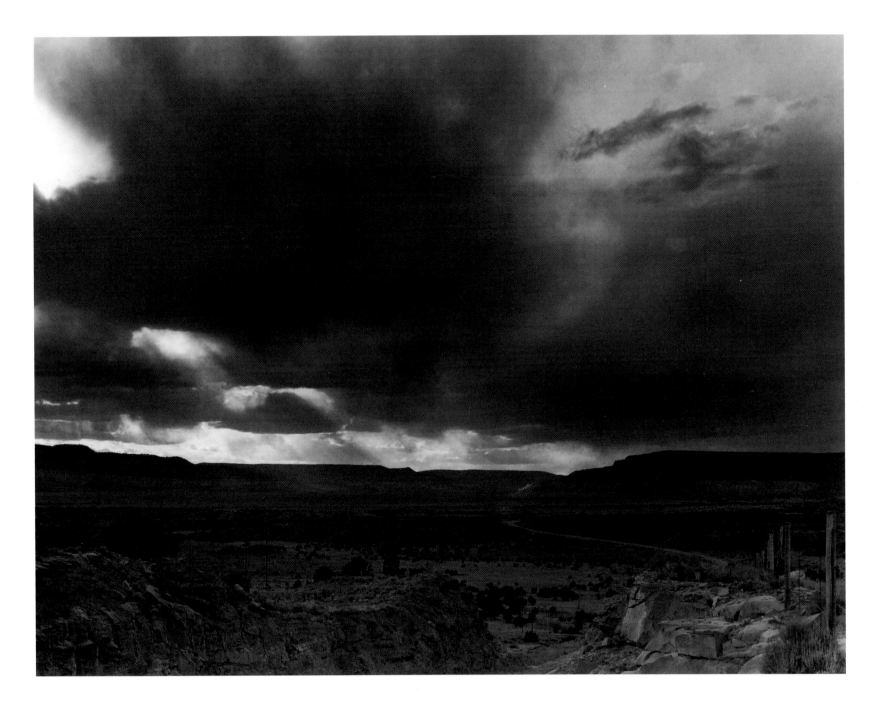

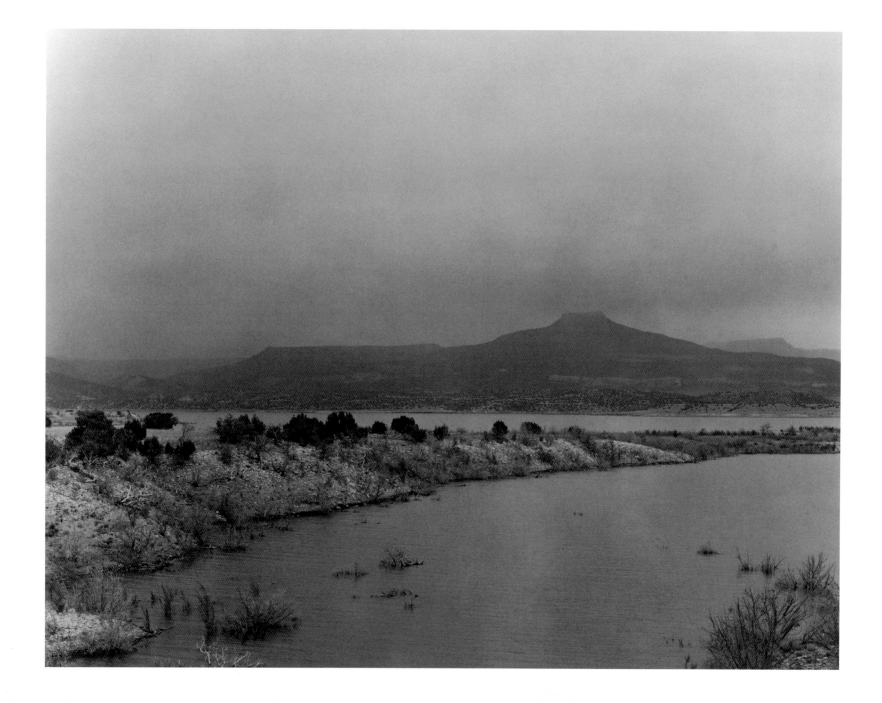

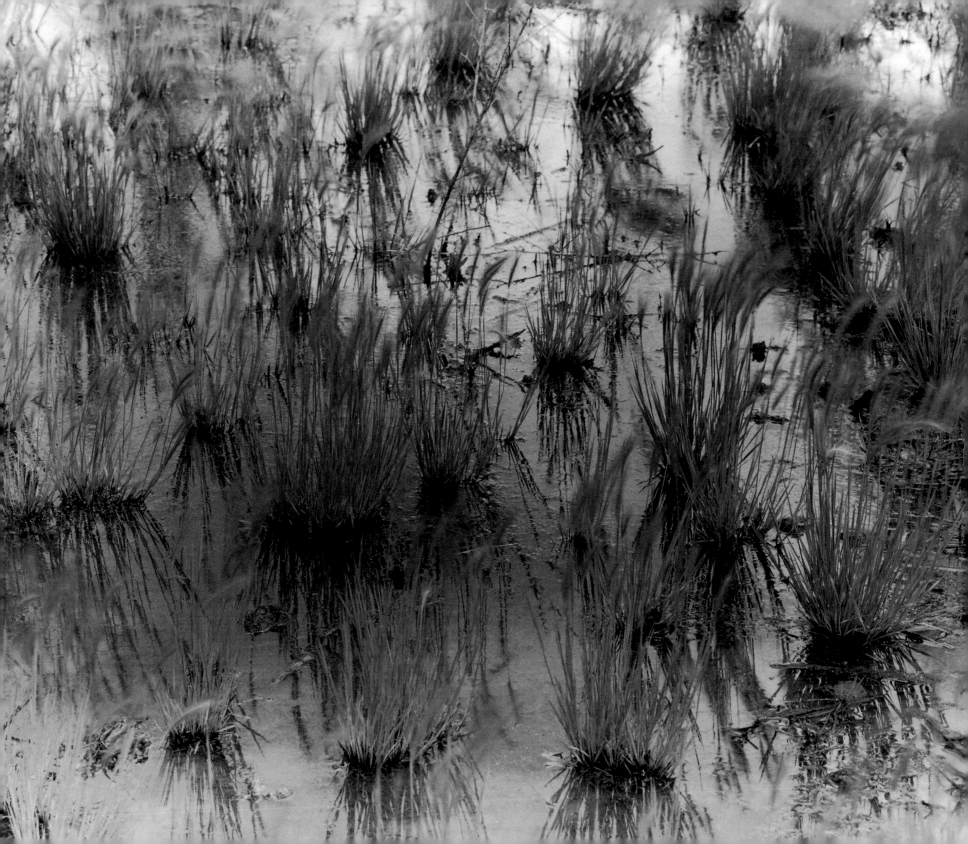

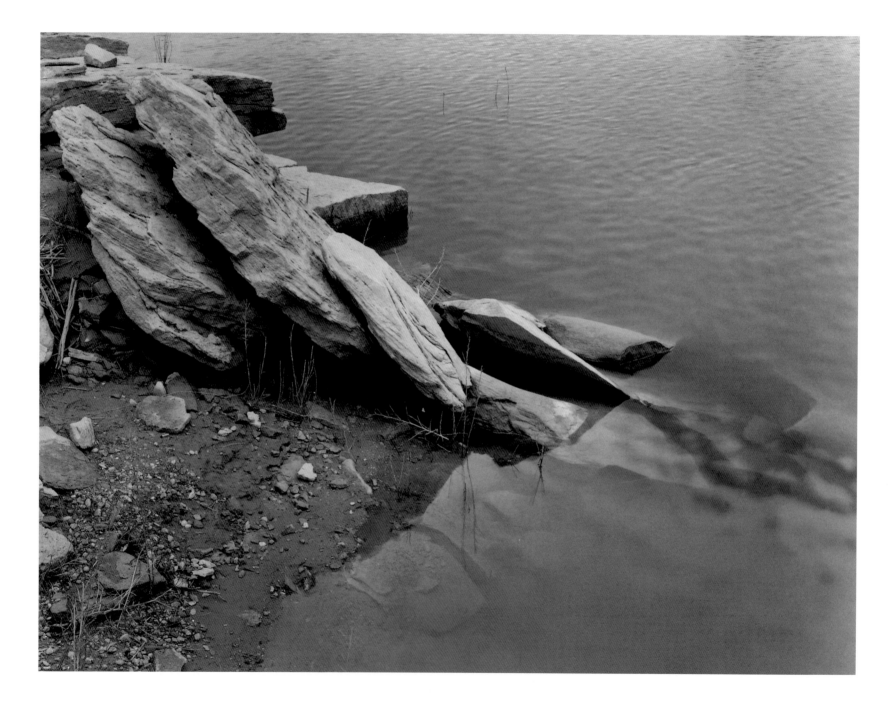

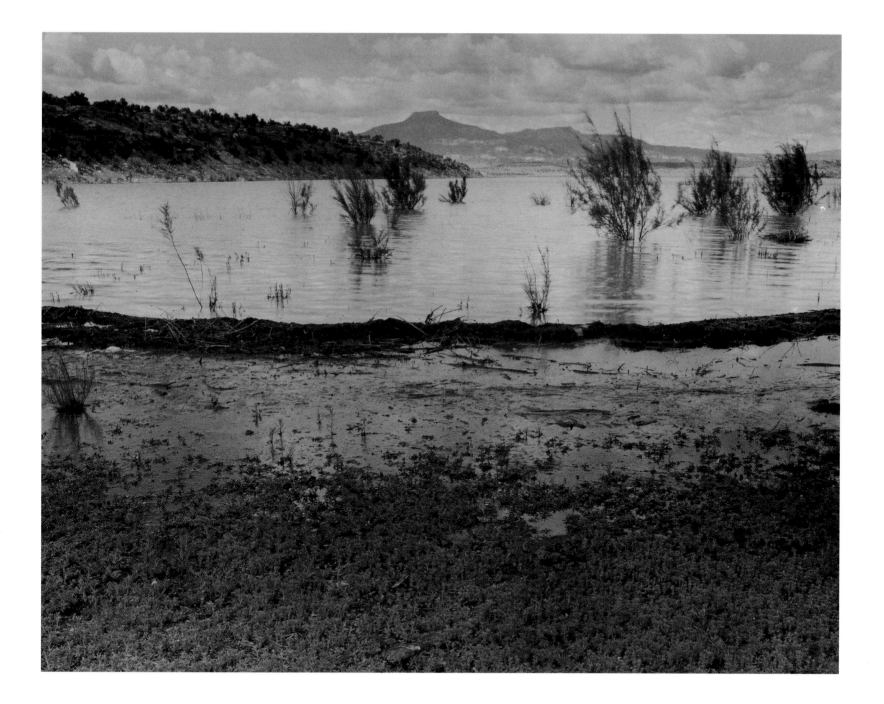

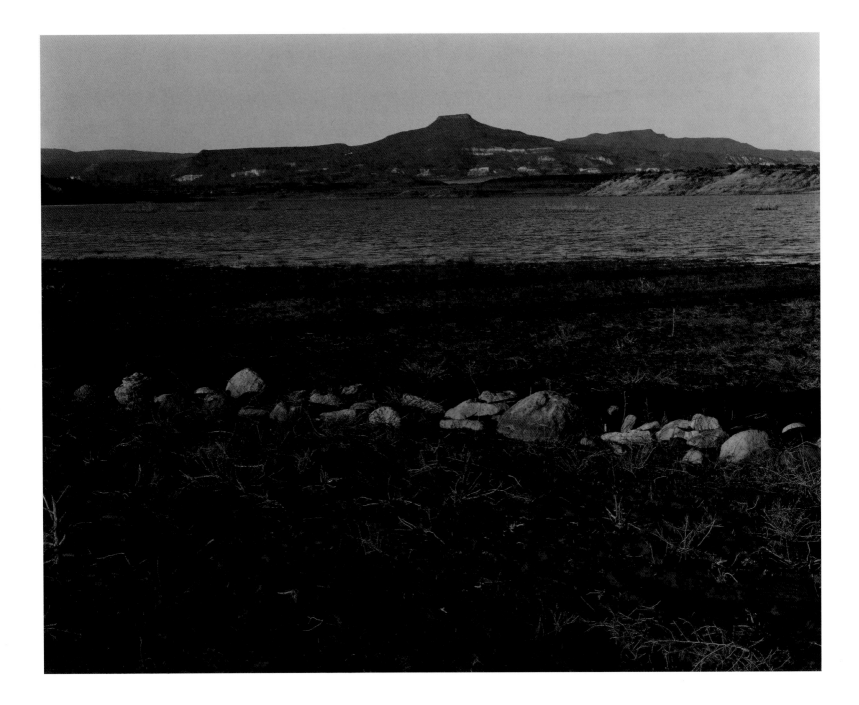

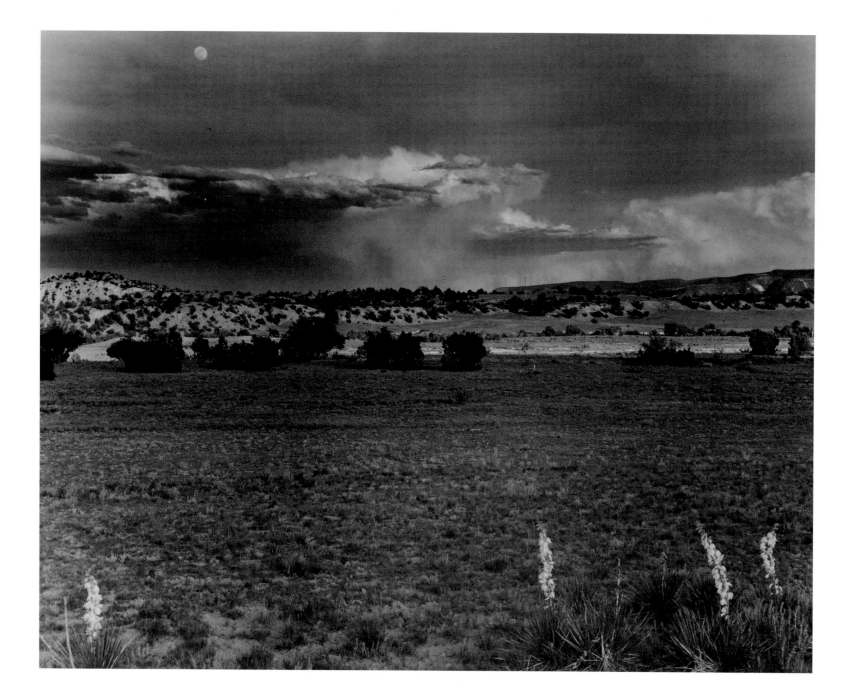

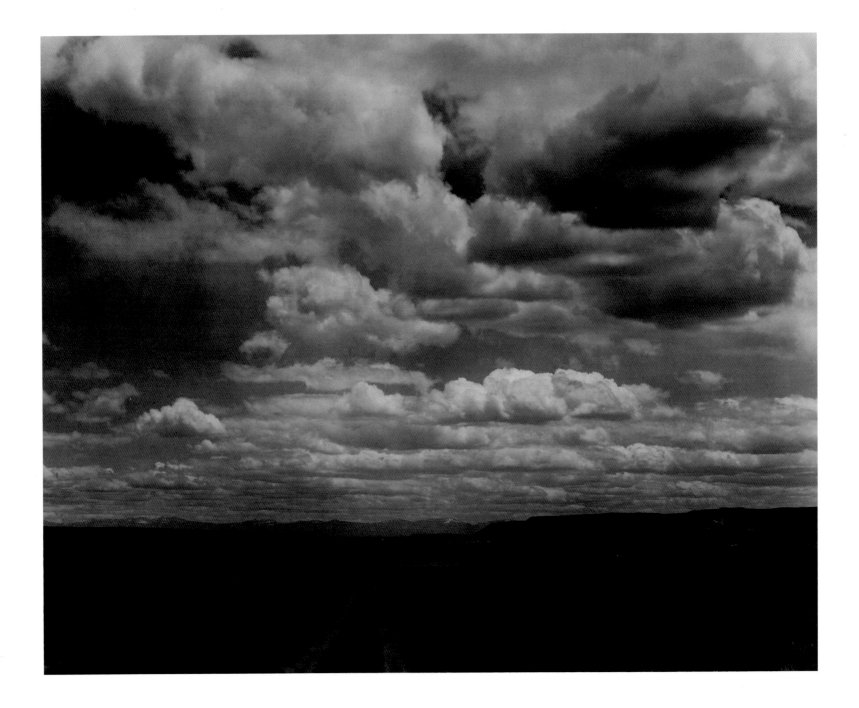

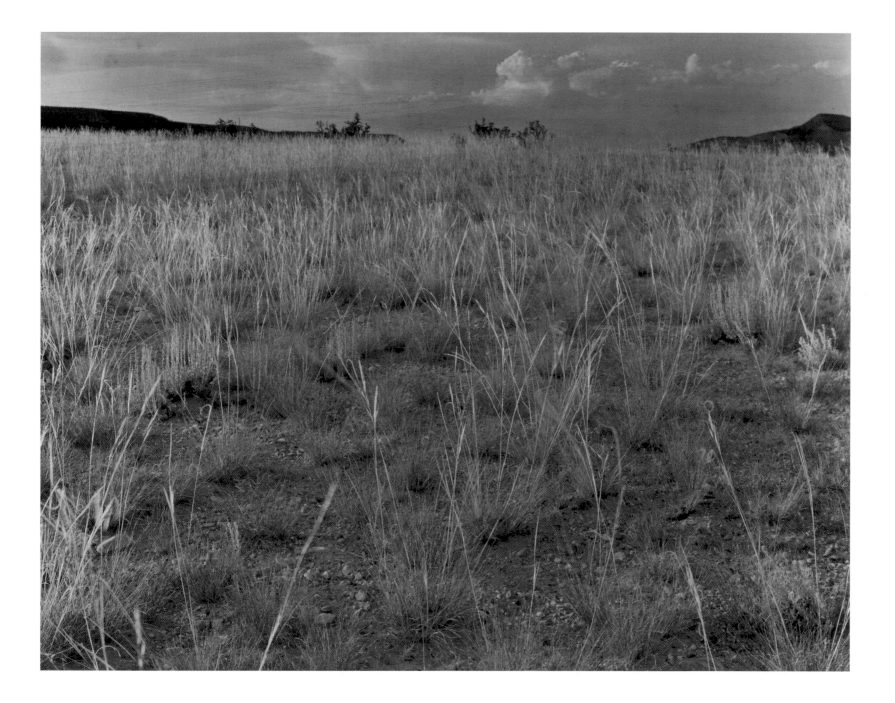

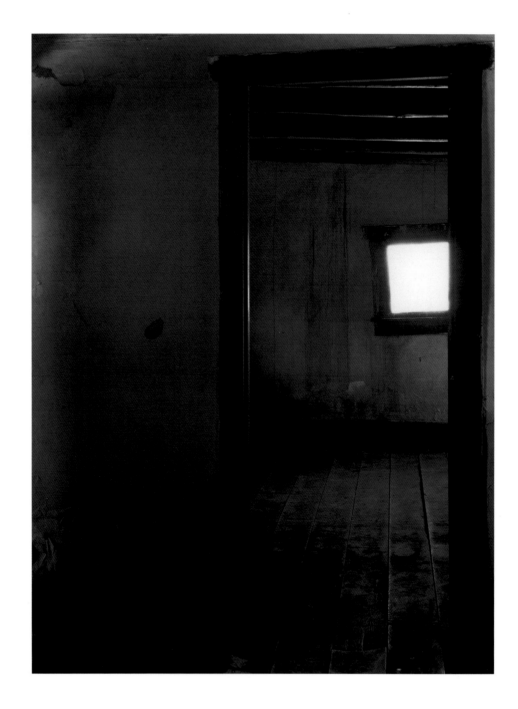

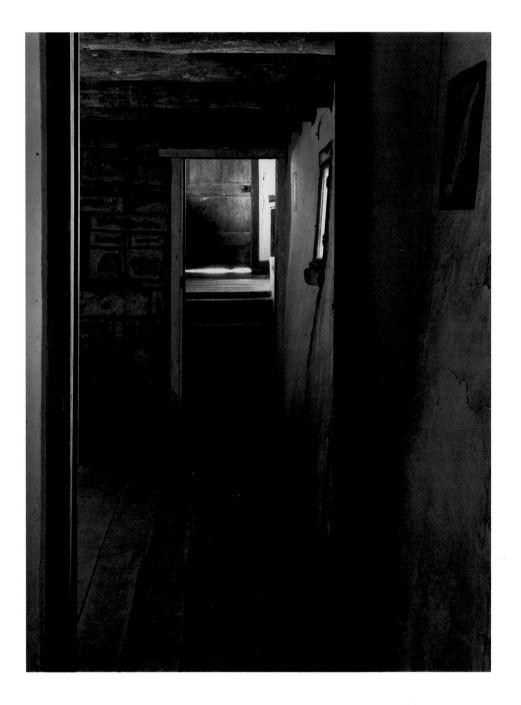

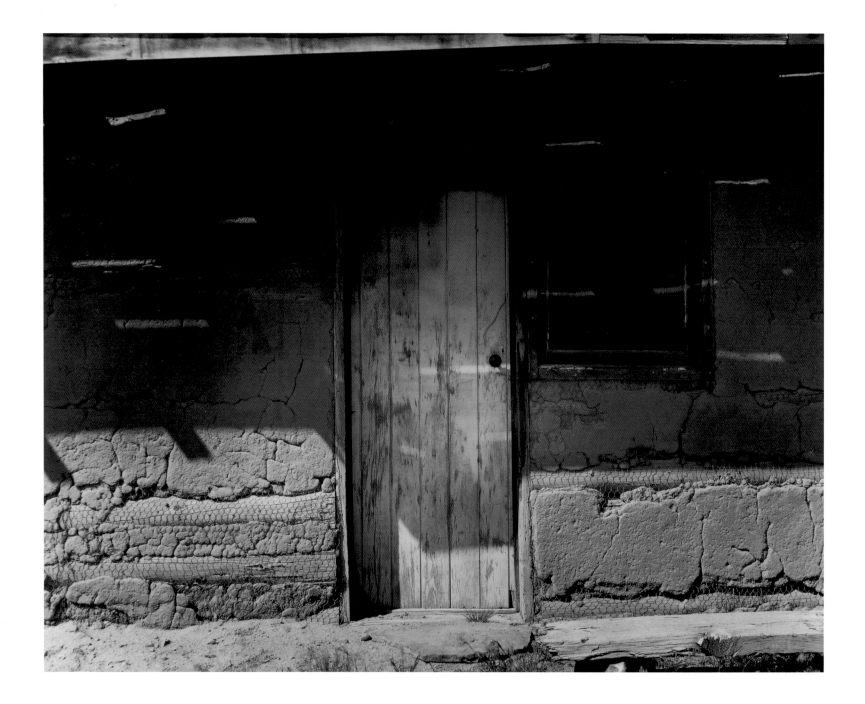

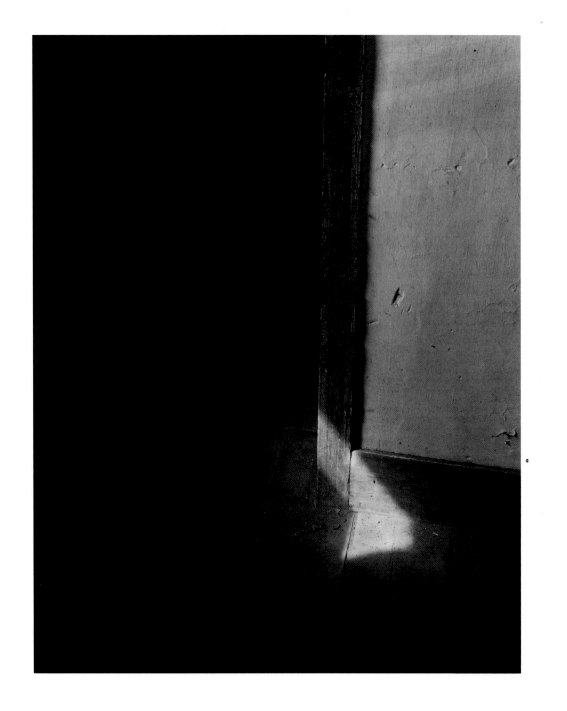

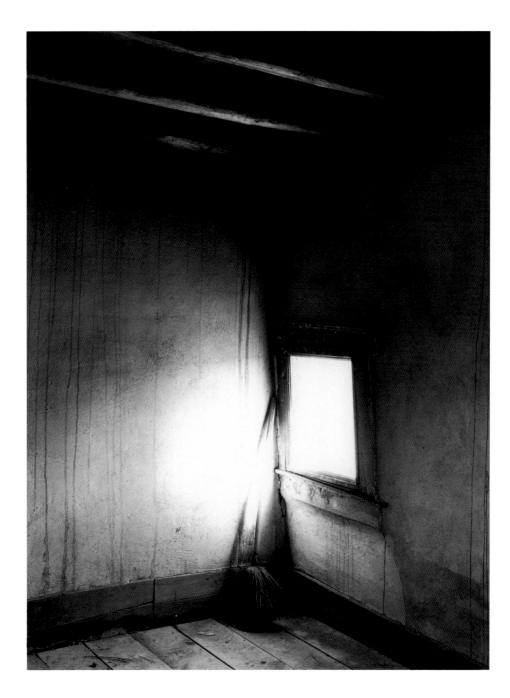

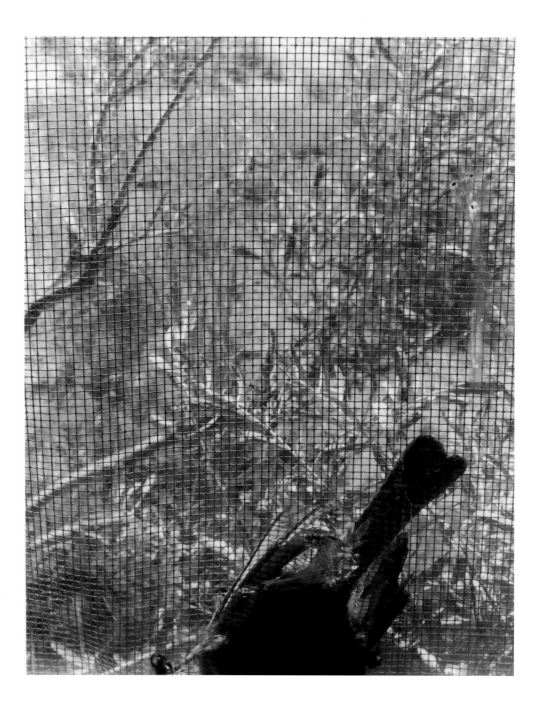

80 Give the country a chance . . . You will find yourself in an unfamiliar territory at first, where the vastness is disquieting, the starkness leaves you empty. You will walk among rocks that tell time differently. Your skin will burn and your hair will lighten. You will find a waterhole and kneel with cupped hands. The reflection you see will not be of the person you once were. Neither is the land.

—Terry Tempest Williams

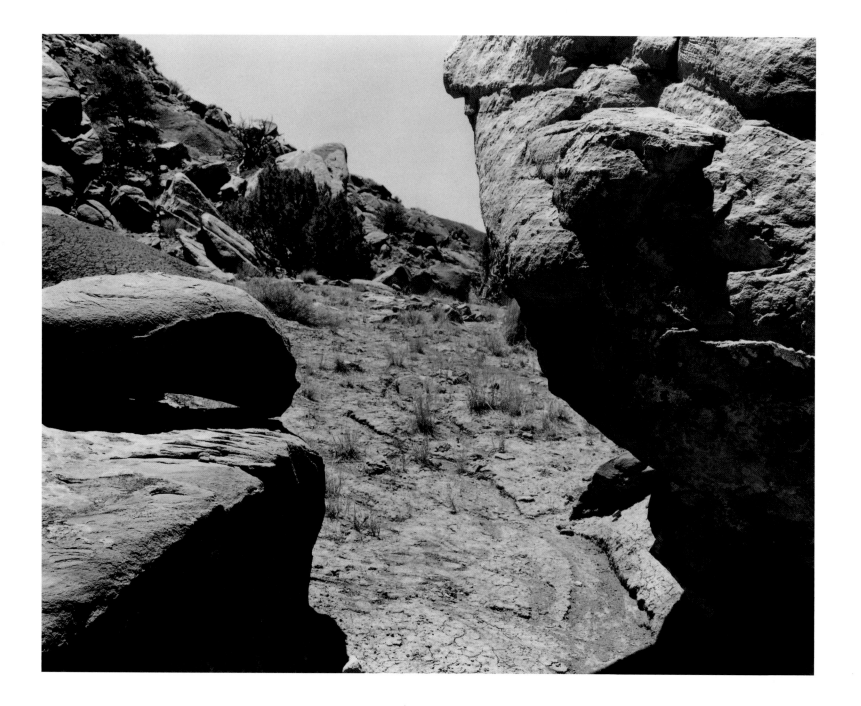

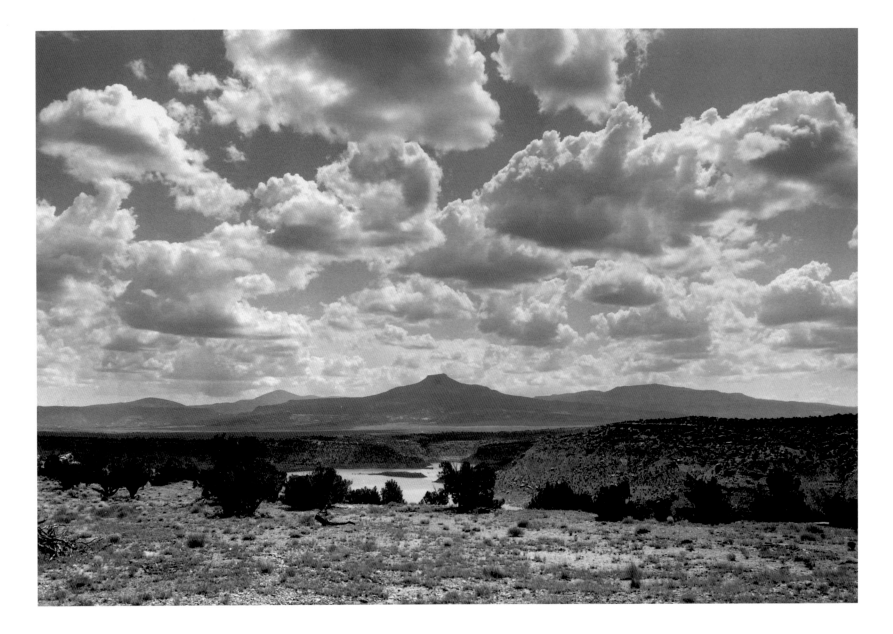

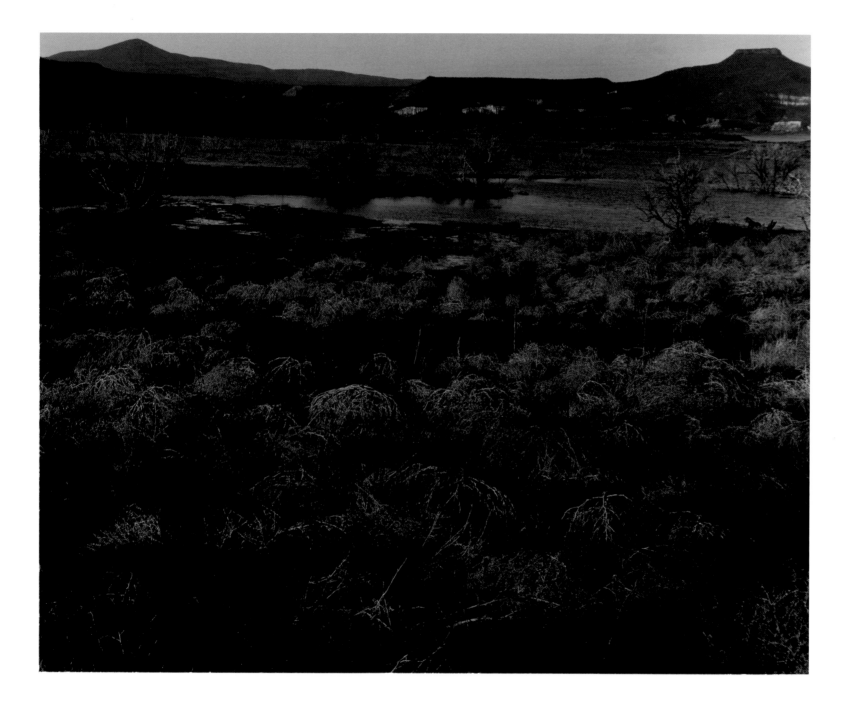

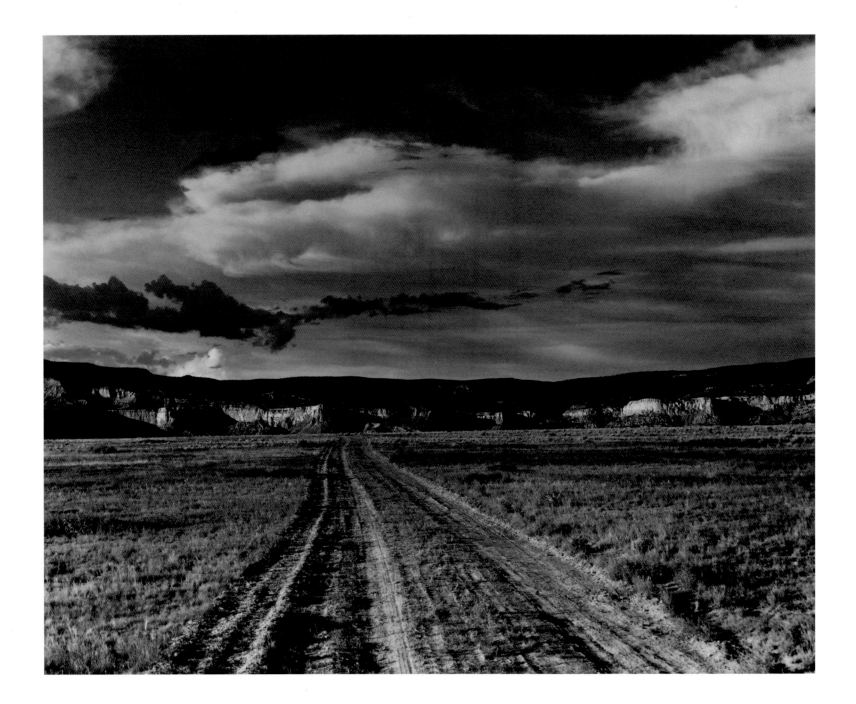

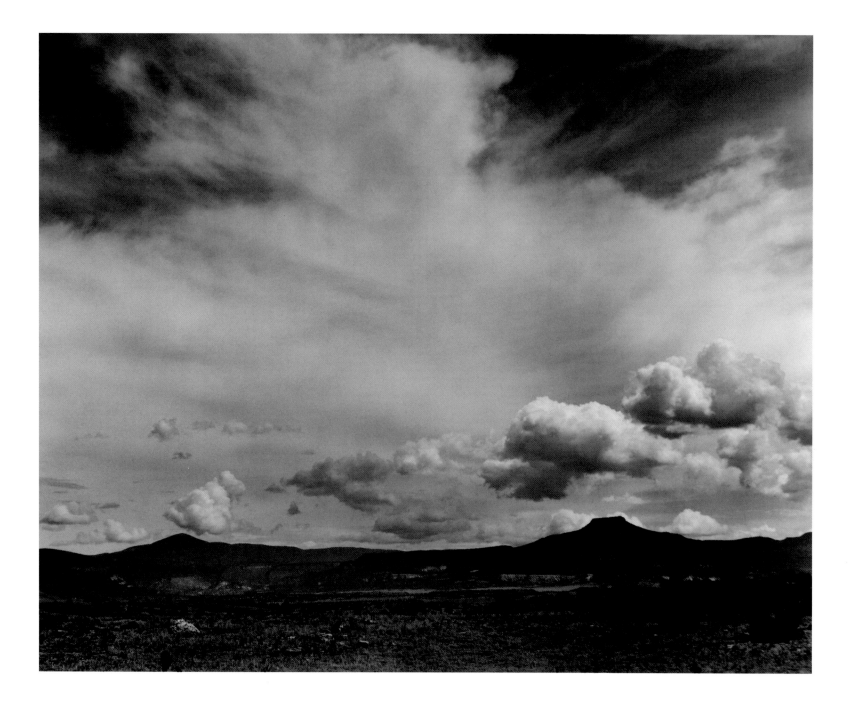

86 The sky was full of motion and change as the desert beneath it was monotonous and still — and there was so much sky, more than at sea, more than anywhere else in the world. The plain was there, under one's feet, but what one saw when one looked about was that brilliant blue world of stinging air and moving cloud. Even the mountains were made ant-hills under it. Elsewhere the sky is the roof of the world; but here the earth was the floor of the sky. The landscape one longed for when one was far away, the thing, about one, the world one actually lived in, was the sky, the sky. —WILLA CATHER

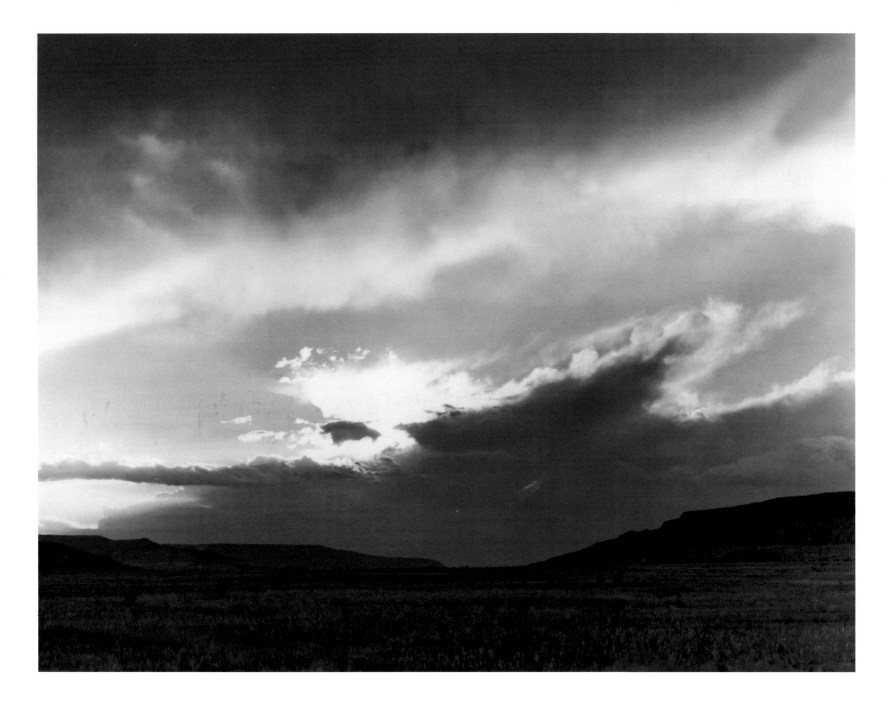

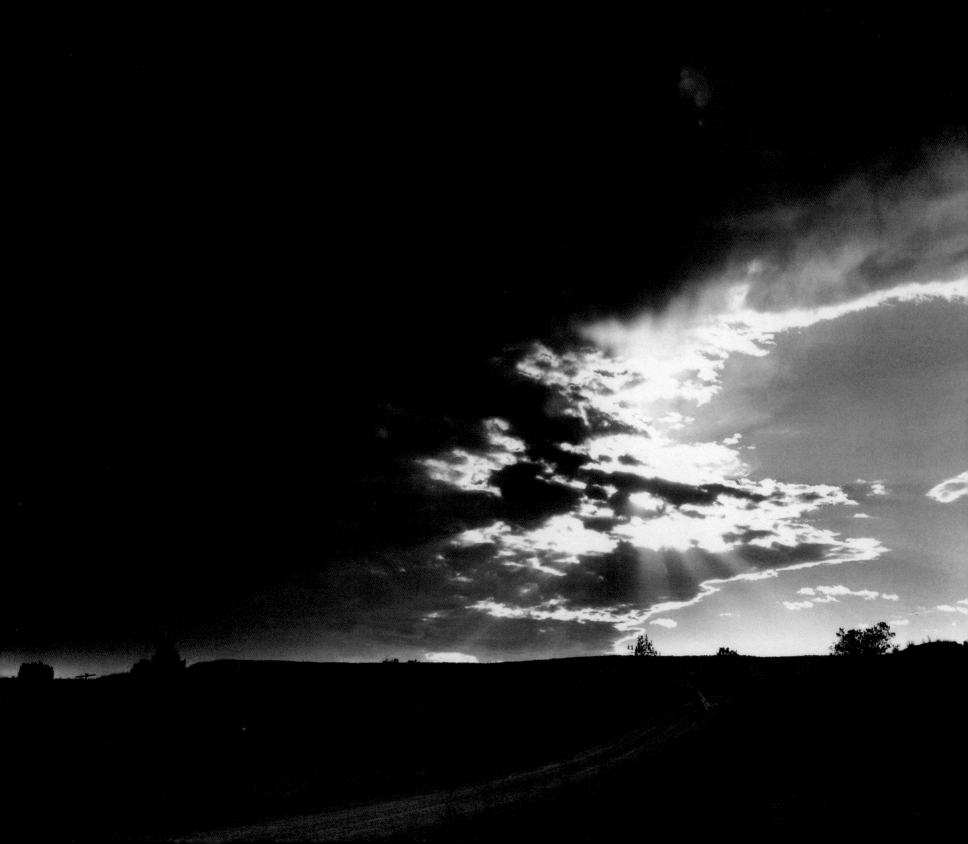

ACKNOWLEDGEMENTS

We have many people to thank for their support and help throughout this project: Rhoda Scheinbaum, David's mother, for her tireless research locating books, quotes and letters related to Ghost Ranch, and Louis Scheinbaum, David's father, for helping her. Our close friend, Tom Wolff, for his research and insights, and our dear friend Alison Kuller, for her thoughtful editing of the text and her extensive search for the words that would complement our photographs.

All the people at Ghost Ranch with special mention for Joe Keesecker, Director, and his wonderful wife Selena Keesecker for their support and loving hospitality during our visits and stays at the ranch. Aubrey Owen and Jim Shibley for their generosity in taking us around the Ranch and suggesting locations for our photography, as well as for the historical information they shared. Dean Lewis and Helen Hall who arranged for us stay at the ranch as Artists In Residence and as teachers in the education program. Judy Shibley who introduced us to long-time ranch visitors and Liddie Miller, who has overseen the Ghost Ranch library for many years. Lynette Gillette, curator of the Ruth Hall Museum of Paleontology who helped us understand and unlock the mysteries of the geology and history of the landscape.

All the hard-working staff at the Ranch that made our stay comfortable, and our workshop participants whose ideas were interesting and stimulating.

Ned Hall whose encouragement and excitement all along the way showed us "hidden dimensions" in our work that were fascinating and led us to deeper insights. Rina Swentzell for her beautiful essay, showing us another viewpoint in looking at the landscape and our photographs. Lesley Poling-Kempes for her generosity in sharing her extensive expertise on Ghost Ranch, and for her hard work in condensing a huge amount of historical background information in a full and thoughtful essay. We believe these essays create a perfect union and context for the photographs. James Enyeart, Elizabeth Glassman, Alex Harris, and Martha A. Sandweiss for their helpful comments.

Ellen Landis, curator of The Albuquerque Museum, who invited us to exhibit this work long before this book was a reality. Our publisher, Ann Gray of Balcony Press, who, with enthusiasm upon seeing the very first prints, immediately agreed to publish this work, and her husband, Peter Shamray of Navigator Press for his knowledge of printing and careful attention to detail in reproducing the images. Designer Kurt Hauser who has created such a beautiful environment for our photographs.

And finally, Ghost Ranch and New Mexico, a constant source of beauty and inspiration.

Our introduction to Ghost Ranch, New Mexico started as a literary one, far from the Southwest in our birth city of Brooklyn, New York, through books containing letters exchanged by Georgia O'Keeffe, Alfred Stieglitz and Ansel Adams. Stieglitz had never traveled to the Southwest himself. O'Keeffe and Adams would correspond sending him detailed descriptions of the land as well as their visual interpretations. Stieglitz was able to "feel" the West through their writings. In a 1937 letter to Alfred Stieglitz, Ansel Adams wrote,

"It is all very beautiful and magical here — a quality which can not be described. You have to live it and breathe it, let the sun bake it into you. The skies and land are so enormous, and the detail so precise and exquisite that wherever you are you are isolated in a glowing world between the macro and the micro, where everything is sidewise under you and over you, and the clocks stopped long ago."

O'Keeffe wrote,

"In the evening, with the sun at your back it looks like an ocean, like water. The color there is different...the blue-green of the sage and the mountains, the wildflowers in bloom. It's a different kind of color from any I'd ever seen — there's nothing like that in north Texas or even Colorado. And it's not just the color that attracted me either. The world is so wide up there, so big."

These letters also formed our first impressions of the West; not the West of television and movies, but the West as seen through the eyes of the artist. We were able, from our urban environment, to create a visual picture of the Southwest for ourselves, and a desire to go to New Mexico. Separately, we visited New Mexico several times and finally moved there (David in 1978 and Janet in 1980). Together, we began exploring our new home.

On a trip home from the Bisti Badlands where David was photographing, we drove the back roads from Cuba, New Mexico into Abiquiu. As we approached Ghost Ranch the sky darkened to a deep silvery purple with the coming of an intense summer rain storm. The air was charged, the mountains lit with an eerily beautiful light. There was raw power everywhere; the sky, the earth, the clouds.

The idea to work there did not come to us right away. It took many more years before we formulated the idea, met with Joe Keesecker, the Director of Ghost Ranch and received his permission to work on this project. As husband and wife and as gallery partners, we already knew we were able to work together successfully in life, but we had never collaborated on a photographic project before. The idea was daunting, but we shared an essential ingredient — we both had a great admiration for the beauty of Ghost Ranch.

Over the next five years, often lugging our equipment, (David shooting with a large and cumbersome 8 x 10 field camera, Janet with a 4 x 5 field camera), our tripods, and most times, our young son Zachary, and on some occasions Janet's 80 year old mother, Esther Goldberg, we set out to cover much of the 22,000 acres that are Ghost Ranch. It was never our intent to document Ghost

Ranch. Keeping our eyes and hearts open, each looking for our own subject matter, we began making photographs. What did this place mean to us? What does it do for us, and how could we interpret it through a lens on a flat piece of light sensitive material? Over time our images began to answer these questions for us, and point us on to others.

Before exploring Ghost Ranch in greater depth for ourselves, our perception of the place was formed very strongly by Georgia O'Keeffe's imagery and influence. The Ghost Ranch logo, a cow skull designed by O'Keeffe, hangs prominently over the entrance to the ranch, and is indeed the first thing that welcomes visitors. O'Keeffe was possessive of the area, especially her favorite mountain, Pedernal, which dominates the landscape from every direction for miles. "It is my private mountain." she explained. "God told me if I painted it enough, I could have it." Her sense of ownership was a bit intimidating, and we knew that we would have to find some way to uncover images, interpretations and viewpoints that would broaden the perception of place.

From the photographs and philosophy of our cherished friend, colleague, and mentor, Eliot Porter, we learned much. While writing in his 1987 autobiography about photography as an art he states,

"But before all else a work of art is the creation of love, love for the subject first and for the medium second. Love is the fundamental necessity underlying the need to create, underlying the emotion that gives it form, and from which grows the finished product that is presented to the world. Love is the general criterion by which the rare photograph is judged. It must contain it to be not less than the best of which the photographer is capable."

This collaboration is an extension of our relationship, another offspring. We can never really be finished with a project such as this. Let this volume be more of a pause in our work and not the final conclusion, as Ghost Ranch will always have a place in our hearts.

JANET RUSSEK AND DAVID SCHEINBAUM

SANTA FE, NEW MEXICO 1997

David Scheinbaum is professor of art at The Marion Center for Photographic Arts at The College of Santa Fe. He assisted photo-historian Beaumont Newhall for 15 years and currently is co-director of Scheinbaum & Russek Gallery Ltd in Santa Fe, New Mexico. He printed exhibition photographs for Eliot Porter and

photograph: Herbert Lotz, Santa Fe

Beaumont Newhall including several limited edition portfolios and published bodies of work. His work has been frequently exhibited throughout the United States and is in the permanent collections of The Amon Carter Museum, Fort Worth, Texas; The New York Public Library; The Center for Creative Photography, University of Arizona, Tuscon; and the Corcoran Gallery of Art, Washington DC.

Janet Russek is co-director of Scheinbaum & Russek Gallery Ltd in Santa Fe, New Mexico. She was assistant to Eliot Porter for 10 years and was a founder of the New Mexico Council on Photography. Widely published and exhibited, her work is in the permanent collections of the Bibliotheque Nationale, Paris, France; Museum of Fine Arts, Museum of New Mexico, Santa Fe, New Mexico; The Gernsheim Collection, University of Texas, Austin; The Rockwell Museum, Corning, New York; the Chase Manhattan Bank Collection, New York.

Edward T. Hall is an internationally known anthropologist and author specializing in intercultural communication. His books, translated into many languages, include *The Silent Language*, *The Dance of Life*, and *West of the Thirties: Discoveries among the Navajo and Hopi*.

Lesley Poling-Kempes is the author of *Valley of Shining Stone: The Story of Abiquiu*; *The Harvey Girls: Women Who Opened the West*; and a novel about northern New Mexico, *Canyon of Remembering*. She lives in Abiquiu with her husband and two children.

Rina Swentzell is a native of Santa Clara Pueblo and now lives in Santa Fe. She received her M.A. in architecture and her Ph.D. in American Studies and works as a consultant and writer on Pueblo culture, aesthetics and architecture.

The tri-tones used in this book to reproduce the look and feel of the gallery prints were developed by Peter Shamray, Jim DuLaney, and Dave Williams of Navigator Press, Inc.

THE GHOST RANCH MISSION TODAY

Arthur and Phoebe Pack loved and cared for Ghost Ranch so it was with both joy and sadness that they decided in 1955 to donate the land to the Presbyterian Church, hoping that it would be used for educational family events. At the dedication of the Ghost Ranch Conference Center, Arthur spoke of the meaning of Ghost Ranch to Phoebe and himself, "There is a treasure hidden here on Ghost Ranch. Some have believed that this treasure is a pot of gold hidden long ago by cattle thieves; some have sought it in the form of oil and uranium; some have been content with finding artistic beauty or old bones and prehistoric skeletons which gave them scientific knowledge of the past." For the Pack's, the treasure was all of the above, and an increased awareness of their spirituality.

This echoes the sentiment and experience of many of the tens of thousands of people who have sojourned here through the years: whether on spiritual retreat, attending the many seminars and workshops in the arts, sciences, and theology, attending training events, grazing livestock on the land, or collecting images by camera, brush and canvas, or simply with eyes wide open.

In 1993, to give expression to its vision and purposes, the leadership of Ghost Ranch drew up the following mission statement:

Ghost Ranch is...
an education and mission center of the Presbyterian Church,
 welcoming people of diverse faiths
 and racial and cultural origins
a center for learning and empowerment,
 preparing women, men and children to grow spiritually,
 strengthen community and give transforming service to
 church and world
a respectful neighbor in historic northern New Mexico,
 offering with love what it has to give
 and accepting with grace what it needs to receive
an advocate for the care of the earth
 and its resources,
living and teaching harmony
 with all of God's creations
an open space for body, mind and spirit,
 offering beauty, encounter and growth
a gift of hospitality and healing
 shared joyfully with all who come
a community of rest, re-creation and renewal,
 serving God and people of questing faith:
 keeper and mender of creation and communities
 seeker and servant of peace and justice,
 light, leaven, salt and neighbor
 in an uncertain world.

We at Ghost Ranch are pleased with this collection of photographic images of our favorite place. We have known and worked with David and Janet as teachers of photography, friends of the Ranch and as photographic chroniclers of the beauty and mystery of this historic place. We hope that the images they have captured will be celebrated by the Ranch's many friends, will provide a valued remembrance of important times shared here, and will introduce many to the Ranch for the first time, encouraging them to experience here the "treasure" hidden in this "open space for body, mind and spirit."

Joe Keesecker
Director of Ghost Ranch

Cover: Animal Tracks, December, 1990

Title page: Sunset Storm Cloud, Piedre Lumbre Basin, July, 1991

page 4: Lone Chair In Snow Covered Alfafa Field, Ghost Ranch Conference Center, December, 1990

Dedication: Two Lone Trees, Painted Desert, June, 1991

page 11: Chimney Rock, July, 1991

page 12: Iris, June, 1993

page 13: Mud Patterns and Brush, Arroyo, July, 1994

page 16: Two Boulders, Red Rock Canyon, July, 1995

page 18: Boulders and Padernal, September, 1991

page 19: Ruins, CCC (Civilian Conservation Corps) Camp, September, 1991

page 20: Hanging Tree and Pack's Point, July, 1995

page 22: Saddle, June, 1993

page 24-25: Badland Formations and Chimney Rock, July 1991

page 28: US. 84 Through the Piedra Lumbre Basin, from Trujillo Hill, August, 1996

page 29: Sunset and Storm Clouds, Near Lookout Point, July, 1991

page 30-31: Storm Over the Piedra Lumbre Basin, from Trujillo Hill, August, 1996

page 32: Living Room Window Looking out at Padernal, Blackie's Place, July, 1991

page 33: Animal Tracks, December, 1990

page 35: Desert Floor in Bloom, June, 1993

page 36: Shade Tree Overlooking Sun Drenched Hillside, July, 1991

page 37: Tree and Chair on Meadow, Ghost Ranch Conference Center, June, 1994

page 38: Fence Posts and Tree in Storm, Trujillo Hill, August, 1996

page 39: Footpaths and Padernal, Piedra Lumbre Basin, May, 1991

page 40: Badland Formations and Chimney Rock, July 1991

page 41: Atop Chimney Rock, Piedra Lumbre Basin, June, 1993

page 42: View from Chimney Rock, Painted Desert, June, 1993

page 44: Fallen Tree Trunk on Badlands, June 1993

page 45: Ruin and Rain Clouds, CCC Camp, September, 1991

page 46: Door in Ruins, CCC Camp, June, 1993

page 47: Root Cellar, Blackie's Place, July, 1991

page 48: Hay Bales, Alfafa Field, Ghost Ranch Conference Center, September, 1991

page 49: Irrigation, High Desert Research Farm, Ghost Ranch, July, 1991

page 50: Tire Swing in Playground, Ghost Ranch Conference Center, 1991

page 51: Apple Orchard, Ghost Ranch Conference Center, June, 1993

page 52: Apple Orchard and Padernal, Ghost Ranch Conference Center, June, 1993

page 53: Rito del Yeso, Box Canyon, December, 1990

page 54: Fence in Snow, Painted Desert, December, 1990

page 55: Bench in Snow below Kitchen Mesa, December, 1990

page 56: Hay, September, 1991

page 57: Farm Implements, June, 1993

page 58: left, Rope, June, 1993; right, Tack, June, 1993

page 59: Door Hasp, High Desert Research Farm, June, 1993

page 60: Cattle Pens and Cowboy, The Feedlot, October, 1991

page 61: Herding Cattle, The Feedlot, October, 1991

page 62: Loading Ramp and Padernal, October, 1991

page 63: Trough, near Mesa Viejas, June, 1993

page 65: Storm Over Piedre Lumbre Basin from Trujillo Hill, August, 1996

page 66: Storm Clouds and Padernal, from Abiquiu Lake, May, 1993

page 67: Marsh, Abiquiu Lake, June, 1993

page 68: Rocks on Shoreline, Abiquiu Lake, August, 1991

page 69: Abiquiu Lake, June, 1993

page 70: Rocks on Shore, Abiquiu Lake, June 1993

page 71: Moonrise and Piñon Dotted Hills, June, 1993

page 72: Road to Abiquiu Lake, June, 1993

page 73: Long Grasses, Lookout Point, June, 1995

page 74: Doorway to Bedroom, Blackie's Place, July, 1991

page 75: Staircase, Blackie's Place, July, 1991

page 76: Front Door, Blackie's Place, June, 1993

page 77: Streak of Light in Doorway, Blackie's Place, June, 1993

page 78: Bedroom with Broom, Blackie's Place, July, 1991

page 79: Bird in Window Screen, Blackie's Place, July, 1991

page 81: Path through Boulders, Red Rock Canyon, July, 1995

page 82: Clouds and Padernal, August, 1991

page 83: Tumbleweeds, Abiquiu Lake, July, 1991

page 84: Road from Lookout Point, July, 1991

page 85: Padernal with Clouds, July, 1991

page 87: Sunset Storm Cloud, Piedra Lumbre Basin, July, 1991

page 88: Sunset, David with his 8 x 10 View Camera, July, 1991

Janet Russek
Title page (detail), page 4:, dedication page, 13, 16, 20, 24–25 (detail), 28, 32, 36, 37, 38, 40, 44, 49, 50, 51, 52, 53, 54, 55, 62, 66, 68, 73, 74, 75, 77, 78, 79, 81, 87, 88.

David Scheinbaum
cover, 11, 12, 18, 19, 22, 29, 30–31 (detail), 33, 35, 39, 41, 42, 45, 46, 47, 48, 56, 57, 58 left, 58 right, 59, 60, 61, 63, 65, 67, 69, 70, 71, 72, 76, 82, 83, 84, 85.

Quotations used with kind permission:

Ansel Adams, in a letter to Alfred Stieglitz from Ghost Ranch, Sept. 21, 1937, reproduced with permission from the Trustees of the Ansel Adams Publishing Rights Trust. All rights reserved.

Mary Austin , *Land of Little Rain*, University of New Mexico Press publisher

Willa Cather, *Death Comes for the Archbishop*, Alfred A. Knopf, Inc. publisher

Georgia O'Keeffe, *Georgia O'Keeffe Foundation*

Eliot Porter, © Eliot Porter, Estate of Eliot Porter

Terry Tempest Williams, *Pieces of White Shell*, Charles Scribners Sons publisher

FINE BOOKS FROM BALCONY PRESS

Merry Ovnick
LOS ANGELES: THE END OF THE RAINBOW
Through well researched historic depictions and colorful anecdotes this book explores
a city's attraction to newcomers as evidenced in its domestic architecture.
180 b/w photos, 384 pgs
ISBN NO: 0-9643119-0-9

Jeanette A. Thomas
IMAGES OF THE GAMBLE HOUSE:
MASTERWORK OF GREENE AND GREENE
This beautiful book uses rich precision photography to explore the sublime details of
this Craftsman period treasure.
100 color photos, 96 pgs
ISBN NO: 0-9643119-1-7

Abigail Gumbiner and Carol Hayden
VACANT EDEN: ROADSIDE TREASURES OF THE SONORAN DESERT
Vacant Eden captures with humor, photographic, and artistic skill, the cultural and
desert motel mirages left behind by a generation who had a love affair with the road.
100 color images, 96 pgs
ISBN NO: 0-9643119-5-X

Margaret Leslie Davis
BULLOCKS WILSHIRE
This elegant book chronicles the efforts of the impressive team of international
architects, designers and businessmen who created Los Angeles' famed art deco
masterpiece.
100 b/w photos, 120 pgs
ISBN NO: 0-9643119-4-1

John Henken and Michael Buckland
THE HOLLYWOOD BOWL: TALES OF SUMMER NIGHTS
This large-format, colorful book captures in scrapbook style, the history, spirit and
legend of the Hollywood Bowl through a series of essays.
160 color photographs, 152 pgs, cloth
ISBN NO: 0-9643119-2-5

Robert Berger and Anne Conser
THE LAST REMAINING SEATS: MOVIE PALACES OF TINSELTOWN
Vivid color images record in lavish detail the spectacular, sumptuous and often
whimsical interiors of 16 of the country's most important movie palaces built during
the '20s and '30s.
100 4-color images, 136 pgs
ISBN NO: 0-9643119-6-8 pb
ISBN NO: 0-9643119-7-6 hc